IMAGES
of America

AMSTERDAM

IMAGES
of America

AMSTERDAM

Kelly Yacobucci Farquhar
and Scott G. Haefner

ARCADIA
PUBLISHING

Published by Arcadia Publishing
Charleston, South Carolina

Library of Congress Catalog Card Number: 2006928537

For all general information contact Arcadia Publishing at: Telephone
843-853-2070
Fax 843-853-0044
E-mail sales@arcadiapublishing.com
For customer service and orders:
Toll-Free 1-888-313-2665

Visit us on the Internet at www.arcadiapublishing.com

*To the residents of the city and town of Amsterdam,
both past, present, and future—this book is for all of you who have
made Amsterdam what it is and will become in the future. Remember,
to get a sense of ourselves and who we are as a community, we have to
understand from where it is that we come.*

CONTENTS

ACKNOWLEDGMENTS

We wish to acknowledge the efforts of many people who have helped us to compile this book. The staff at the Montgomery County Department of History and Archives, the staff and trustees at the Old Fort Johnson Historic Site/Montgomery County Historical Society, Mary Donohue at the Fulton-Montgomery Community College Evans Library, LaVerne Stark at the Hagaman Historical Society, the Walter Elwood Museum, St. Mary's Catholic Church, retired Montgomery County historian/record management officer Jacqueline Murphy, Diane Smith, and Jonathan Hubbs.

Because the photographs in this book were taken from a number of different collections, we wish to acknowledge those collections here and use the following abbreviations throughout the book:

H&A	Montgomery County Department of History and Archives
OFJ	Old Fort Johnson Historic Site/Montgomery County Historical Society
FMCC-WEM	Photograph copyright by Walter Elwood Museum; digital image copyright by Fulton-Montgomery Photographic Archives, Evans Library—Fulton-Montgomery Community College
FMCC-FJ&G	Fonda, Johnstown, and Gloversville Railroad Collection at the Dorn Room; digital image copyright by Fulton-Montgomery Photographic Archives, Evans Library—Fulton-Montgomery Community College
HHS	Hagaman Historical Society

INTRODUCTION

Situated along the shores of the historic Mohawk River, the town of Amsterdam in Montgomery County is the center of New York State's heritage corridor. The first record of sale or transfer of property within the present city of Amsterdam was when a local native known as Rode de Maquaase granted land to Adam Vrooman and Isaac Morris in 1688. This deed gave the flatlands between the west boundary of Adriutha (now Cranesville) and the eastern boundary of what is now Guy Park. In 1716, this land was transferred to a Mr. Phillips of Cranesville. The Hoofe patent of 1727 comprised one square mile extending to each side of the Mohawk River. West of this was the Wilson/Abeel patent of 1706. Sir William Johnson, the British superintendent of Indian Affairs, subsequently acquired both of these.

In 1708, the great Kayaderosseros patent of some 700,000 acres was fraudulently acquired by some "gentlemen of Albany," the western boundary of which was the Kayaderosseros Creek at present Fort Johnson. For over 60 years, the local Mohawks repudiated the sale of this land grant and would not allow settlers on it. This may be the reason why there were no real or permanent settlements until late in the 18th century at Amsterdam, while all around the hamlets of Cranesville, Fort Johnson, Fort Hunter, and Minaville were being settled. Through the efforts of Sir William Johnson, the grant was cut down to about 23,000 acres, extending north through the present Montgomery, Fulton, and Saratoga Counties. With the settlement of this claim, Johnson was able to petition for the formation of a new county in 1772 and named it Tryon, after the colonial governor of the New York province. The new county covered a landmass that was almost one-third of the entire province and comprised five districts. Easternmost of these was the Mohawk district, which extended westward for about 25 miles along both sides of the Mohawk River from the Albany County line, at that time located near the present Hoffmans. Royal governors, however, fell out of fashion during the Revolution, and in 1784, the name of the county was changed to memorialize Gen. Richard Montgomery, who died during the siege of Quebec in 1775. Also in the post-Revolutionary era, a division of the Mohawk district in 1788 brought the name Caughnawaga to the Mohawk area on the north side of the river. This change was short-lived, however, for in March 1793 four towns were created out of the old district—Johnstown, Broadalbin, Mayfield, and Amsterdam. By 1798, according to *Morse's Gazetteer* of that year, the township had 235 residents.

Within the boundaries of the present city of Amsterdam there seemed to be no notable settlements until the arrival of Joseph Hagaman and Albert Vedder around the time that the Revolution ended. It is said that Hagaman arrived here first and staked a claim by dumping a load of stone near the outlet of the Chuctanunda Creek and went back to Dutchess County to collect his wife and family. When he returned the following spring, he found his claimed site occupied by Albert Vedder. Hagaman continued north up the creek a couple of miles where he bought 400 acres and established Hagaman's Mills. Vedder, meanwhile, erected a sawmill and gristmill on the spot where the Chuctanunda Mills once operated. He named the settlement Vedder's Mills, which by about 1794 was called Veddersburg. During the first decade of the 19th century, that name was dropped in favor of the name Amsterdam.

The village of Amsterdam remained unincorporated until 1830. A village president and several trustees were elected and met haphazardly until a second charter was granted in 1854, when about one-third of the town of Amsterdam's 4,128 residents were living within the corporate limits of the village. A third village charter giving more powers under home rule authority was granted by the legislature in 1874. A committee of private citizens organized as the board of trade successfully petitioned the state legislature in 1884, and the Amsterdam City Charter was granted on April 16, 1885.

As early as 1802, a passing traveler noticed four gristmills, two oil mills, an iron forge, and three sawmills on the banks of the Chuctanunda Creek. The opening of the Erie Canal in 1825 and the construction of the Utica and Schenectady Railroad in 1836 paved the way for the industrial growth of Amsterdam that would make it a household name across America. The earliest accounts of textile manufacturing here go back to the late 1830s when William K. Greene, then a resident of Poughkeepsie, read in the *New York Times* that a building in Hagaman's Mills might be rented for $100 a year. He rented the property, bought a half dozen handlooms for carpet making, and hired a couple of weavers. During the early 1840s, he was joined by John Sanford for a partnership that lasted briefly, after which Greene withdrew to enter the knit goods business with John McDonnell. Their site was on the east side of Market Street opposite the street that still bears the Greene family name.

Sanford's carpet operations were continued in a stone building on the east side of the Chuctanunda Creek near Prospect Street, and during the early 1840s, his son Stephen joined the first John Sanford. When the founding father withdrew in 1855, the son carried on alone for several years after which a third generation, Stephen's sons John and William, were taken into the business. The family-owned company became S. Sanford and Sons. One brick building after another was erected until they lined both sides of the creek and neighboring streets Prospect, Church, Shuler, Willow, and Park.

From 1857, when John Maxwell designed and built much of the machinery used by he and his partner in Amity Mills, Adam W. Kline, at Rock City, there was continued expansion in the field of textiles in Amsterdam.

An example of the new opportunities was seen in the 1871 organization of the first Riverside Mill of Warner, DeForest, Sugden, and Faulds, whose knitting operations included a plant in the rear of the Central Hotel on Market Street. About 400 mill hands were being employed in 1890. The most impressive growth was in 1886 when four textile firms came on the scene within a year, Yund, Kennedy, and Yund on Eagle Street, Gardiner and Warring on Yoeman Street, the Royal Mills of Van Brocklin and Snyder at the Hamilton Street and Corey Street corner, and L. L. Dean, who opened the Park Knitting Mills on Lyon Street.

Population and industry continued to expand in Amsterdam until 1930 when a long, slow period of decline set in, culminating in 1955 with the announcement that the Bigelow-Sanford Company intended to close the 125-year-old Amsterdam facility and move production to the south. The opening of the New York State Thruway Interchange 27 in 1955 heralded even more drastic changes for Amsterdam. The construction of the Route 30 arterial and the connections across the Mohawk River linking the thruway necessitated the demolition of about 27 acres of the old downtown business district between 1960 and 1973. The Urban Renewal Act passed by the Amsterdam City Common Council in 1967 set apart another 78 acres of the downtown for demolition and construction of a new hotel on Market Street, several office plazas, and the Amsterdam shopping mall that opened in 1977. Also in the 1960s came a general trend for businesses to relocate to the outskirts of the city. The Old Collins Farm and the Sanford Hurricana Farm on Route 30, north of the city, were gradually transformed into new shopping districts.

Amsterdam's ethnic diversity is clearly evident in the numerous churches and fraternal organizations that formed in the city. These ethnic groups generally settled in the neighborhoods in which they worshipped. Today Amsterdam is a city transformed from its 18th-century frontier and from the 19th-century industrial giant that it was at one time. The 21st-century Amsterdam survives as a suburban community and a tourist destination as the "Gateway to the Adirondacks."

One

EARLY AMSTERDAM

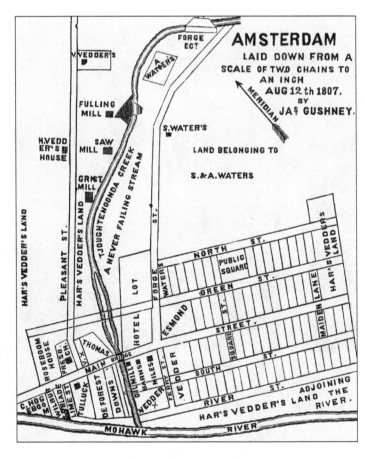

In its early days, Amsterdam was a small frontier town. In 1813, the settlement contained a church, a schoolhouse, 25 dwellings, some stores and shops, and about 150 inhabitants. (H&A.)

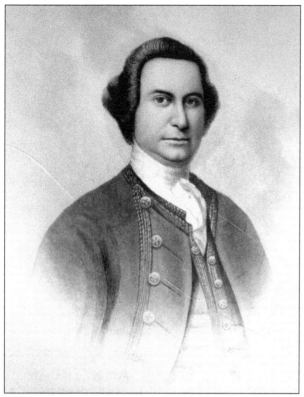

Sir William Johnson was commissioned "Superintendent of all the affairs of the Six Nations and other Northern Indians" in 1756. He provisioned British military posts, worked to keep the British and American Indians friendly and in cooperation, and served in the New York colonial legislature. Johnson won military fame as a major general of the provincial militia and commander when French forces under Baron Dieskau were defeated at the Battle of Lake George in 1755. (OFJ.)

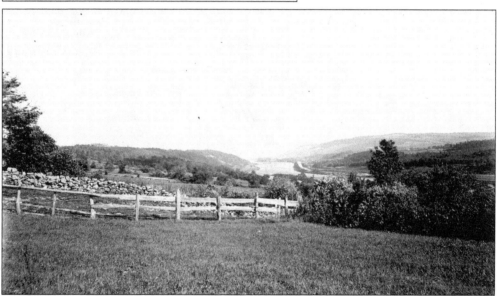

Sir William Johnson was only 23 years old when he came to New York to oversee the landholdings of his uncle, Adm. Sir Peter Warren, south of the present city of Amsterdam. William purchased a tract of land north of the Mohawk River in 1739. In 1743, he built a house there called Mount Johnson and developed a fur trade with the Native Americans that became the basis of his fortune. In this view of the Mohawk Valley from Swart Hill, the landscape may have looked similar to Sir William Johnson. (H&A.)

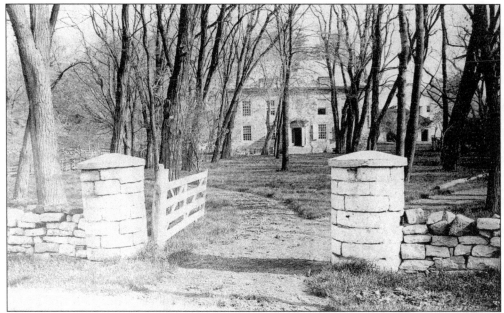

Out of the profits of the fur trade William Johnson purchased about 500 acres of land. Acting as his own architect, he built a new house about a mile west of Mount Johnson in 1749. At the start of the French and Indian War in 1755, Johnson fortified the house, seen here in 1888, against attack, and it became an important military post and Native American council site during the war, which lasted until 1763. (OFJ.)

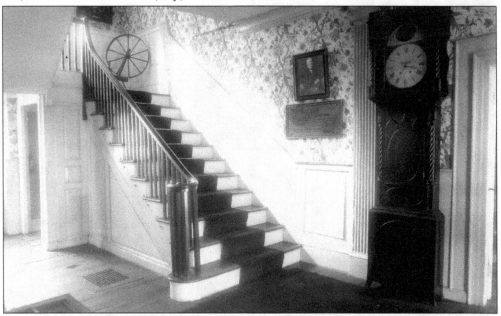

This elegant structure, Fort Johnson, was originally part of a larger complex that included a gristmill, a sawmill, a bake house, and other farm buildings. Here many large conferences were held between the British and the Iroquois Nation, including one in 1755 where 1,106 Native Americans camped around the house for nearly three weeks. The front hall of the Johnson house is seen here around 1910. (OFJ.)

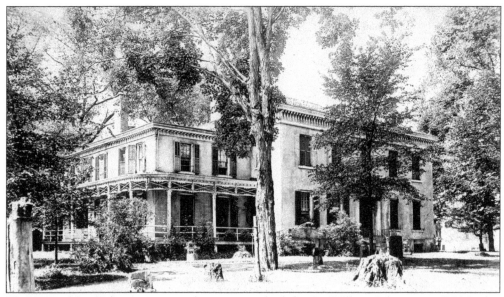

The original house here was a wooden structure built by Sir William Johnson in 1766 for his nephew Guy Johnson, who married Sir William's daughter Mary. The original house burned in 1773, and the present stone structure, Guy Park Manor, seen here in 1901, was finished in 1774, the year Sir William Johnson died. The next year, Guy Johnson and his family fled to Canada, and all of the Johnson family landholdings were seized by the Tryon County Committee of Sequestration and sold at auction. (OFJ.)

Amsterdam's earliest settlers owe their prosperity to the waters flowing in the Chuctanunda Creek. A company of ambitious businessmen, in 1865, formed the Amsterdam Water Works Company, to improve the power of the Chuctanunda and water output by creating a reservoir with dams and gates. Enlarging the reservoir in 1872 to 567 acres resulted in attracting thousands of workers to the city's prospering industries. (H&A.)

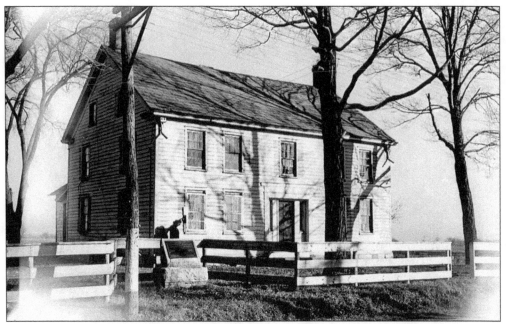

Located on the southeast corner of Route 30 North and Wallins Corners Road, this house, belonging to James Allen, was built prior to 1793. James Allen was one of the first commissioners of the town of Amsterdam in 1793, and it was here, at his inn, that the meeting was held to change the name of the town from Veddersburg to Amsterdam around 1809. (Scott G. Haefner.)

The old Manny Road House, owned by Gabriel Manny Jr., was located on the north side of East Main Street. The tavern and stage house, on the Mohawk Turnpike, served travelers far and wide between 1795 and 1840. The Mohawk Turnpike was intended for traffic transporting goods to and from Albany westward. The Manny Road House provided people, and their animals, food and shelter along their travels. (OFJ.)

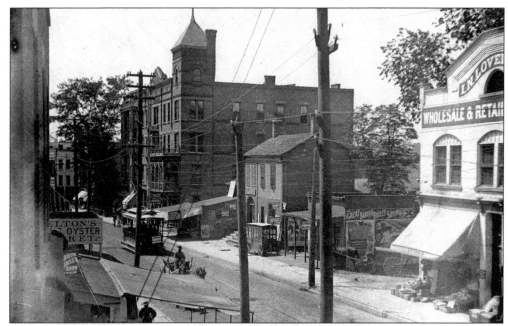

The home of Maj. Gen. Benedict Arnold (1781–1849) sat on Market Street (center of photograph) next to the Central Hotel prior to construction of the Blood Building. Arnold served as a U.S. congressional representative for two years under Pres. Andrew Jackson, while his political life at home included town supervisor and president of the village board of trustees. The house was demolished before 1910 and is now the site of the Best Western. (H&A.)

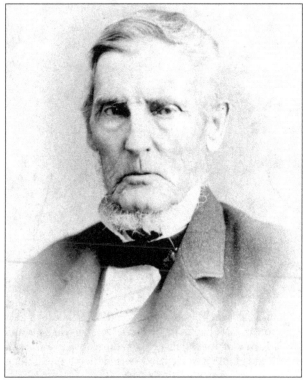

Born in 1803 on his parents' farm near Manny's Corners, Thomas Bunn served as Montgomery County sheriff from 1840 to 1844. His other occupations included being the postmaster and owning a hotel in Tribes Hill, as well as having connections with several Amsterdam banking houses, including being president of the People's Savings Bank at the corner of Main and Church Streets in 1875. (OFJ.)

14

Upon moving back to Amsterdam, Bunn amassed a great deal of land when he purchased the Bovee and Arnold farms. Around 1862, he began selling off parcels of this land in the areas of Greene Street and where the academy once stood. Thomas and Bunn Streets were named for him. Pictured is the Bunn farm on Market Street. (OFJ.)

Located at the corner of Prospect Street and Brookside Avenue, the Thomas Bunn house was originally built by Rev. Halsey Wood, pastor of the Presbyterian church. The home had large airy rooms with six fireplaces. The dining room fireplace was hung with a crane and had a stone hearth measuring 4 feet wide by 10 feet in length. Thomas Bunn, as a youth, cut the stone in the Amsterdam quarries. (OFJ.)

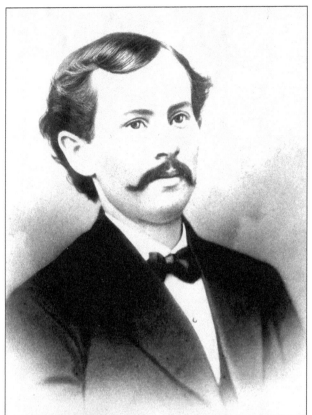

John S. Maxwell (1849–1925) served Amsterdam very well during his lifetime, first as an industrialist, then as a public servant. Later in life, Maxwell became an attorney and procured pensions for veterans of the Civil War. Maxwell's service to his community was rounded out as he held the positions of city recorder and district attorney. This portrait of Maxwell dates from around 1876. He is buried in the Green Hill Cemetery. (OFJ.)

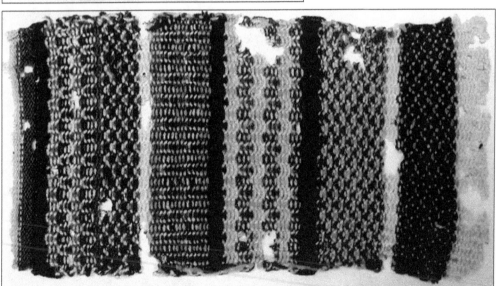

Partnering with Adam W. Kline, Maxwell got his start in the knitting business when the pair opened their first mill in 1856 on the Chuctanunda Creek in the area of Amsterdam known as Rock City. Reputedly the first piece of fabric knit in Amsterdam, this piece was presented by John S. Maxwell to the Montgomery County Historical Society and remains a part of its collection. (OFJ.)

16

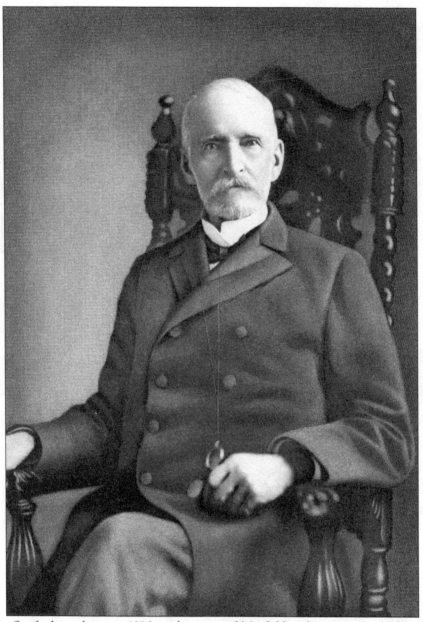

Stephen Sanford was born in 1826 in the town of Mayfield and was a son of John Sanford, who, in 1842, established the Sanford Carpet Mills in Amsterdam. Stephen was educated at the Amsterdam Academy, Georgetown College, D.C., and at the United States Military Academy at West Point. In 1844, he entered his father's mills and became a partner in 1848. After the mills were destroyed by fire in 1858, he purchased his father's interest and rebuilt what was to become the Bigelow-Sanford Carpet Company. Stephen went on to become Amsterdam's most philanthropic citizen, including building the Children's Home, as a memorial to his son William, and the Sarah Jane Sanford Home for Elderly Women. Stephen had his hand in many other areas, including banking. He was one of the trustees organizing the Green Hill Cemetery Association in 1857 and was a representative to the U.S. Congress from 1869 to 1871. Stephen died in 1913. (OFJ.)

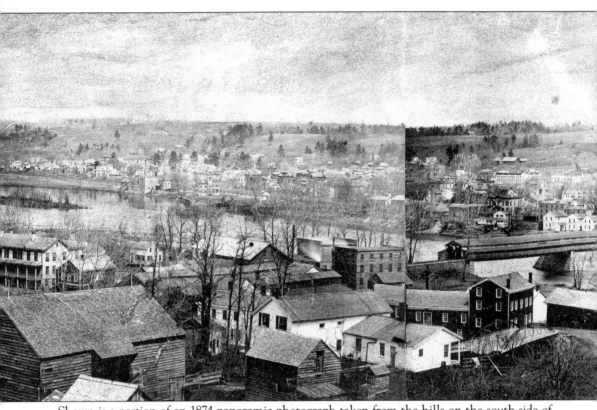

Shown is a portion of an 1874 panoramic photograph taken from the hills on the south side of the Mohawk River looking north toward Amsterdam. In the foreground are the Erie Canal and the community of Port Jackson. Spanning the Mohawk River is the wooden covered bridge built

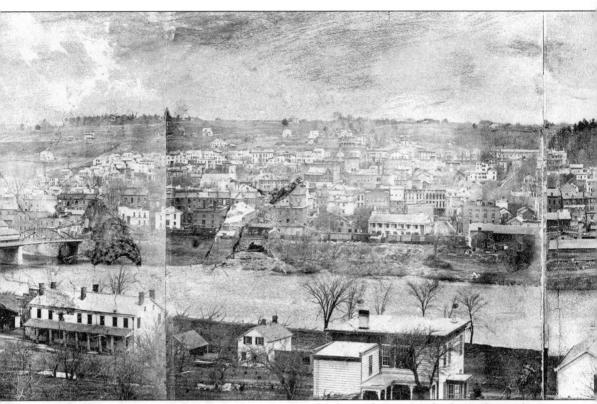

in 1864. This panorama is evidence of how the city's landscape has so greatly changed over the last 130 years. (OFJ.)

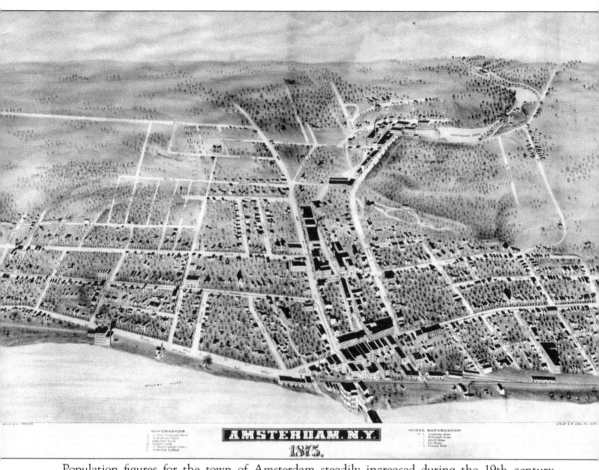

Population figures for the town of Amsterdam steadily increased during the 19th century. However, with figures decreased from 11,710 in 1880 to 2,948 in 1890, the drop was due to the incorporation of the city of Amsterdam in 1885. The growth of Amsterdam village dramatically increased in the latter 19th century due to the booming industry. The village in 1880 counted 9,466 residents, and by 1890, the fledgling city had a population of 17,336. (H&A.)

Two

INDUSTRY AND COMMERCE

The businesses on East Main Street between Bridge Street and the First National Bank in 1851 were (1) Chandler Bartlett Boots and Shoes, (2) Hawley and Cady Dry Goods, (3) FTB Sammons Clothing, (4) William Taylor Hides and Feed, (5) John J. Bassett Drug Store, (6) Warring and McCowatt Hardware, (7) Alexander Clothing, and (8) American Hotel. This was known as "Fiddlers Row." The one-story building on the left spanned the Chuctanunda Creek. (OFJ.)

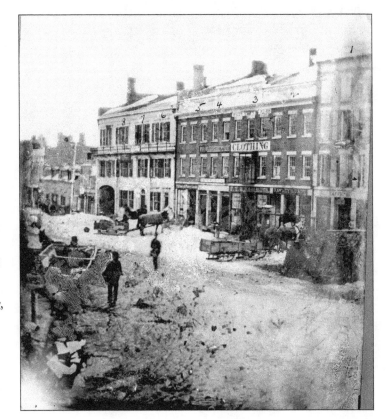

This 1842 brick structure was the early office building for the Sanford Carpet Mills complex at the corner of Church and Prospect Streets. Today it houses the Noteworthy Indian Museum, exhibiting a collection of Native American objects. (OFJ.)

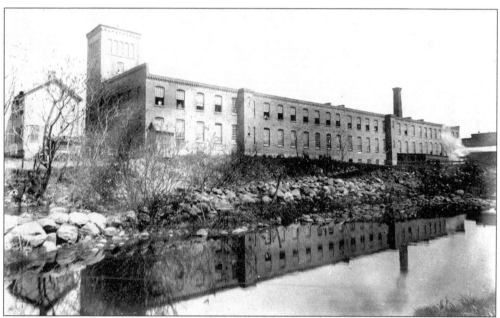

John Sanford began making carpets in Amsterdam in 1842 with 100 handlooms, 12 three-ply looms, and 28 tufted rug looms. Once his son Stephen joined him in business, the elder Sanford withdrew from carpet making. While John went on to ensure a steady water supply to Amsterdam with the creation of the Galway Reservoir, Stephen's leadership allowed the company to flourish and thrive, growing to one of Amsterdam's most prominent businesses. (H&A.)

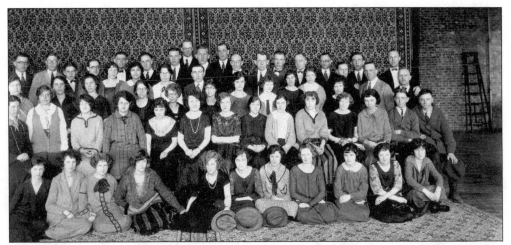

The Bigelow-Sanford office group sits on an Axminster Rug in 1924. Pictured from left to right are (first row) H. Covey, J. McNaughton, J. Mason, E. Rotbell, F. Sweet, G. Haner, E. McQuatters, K. Bowles, G. Netto, ? Geddis, and M. Costello; (second row) F. Tetlow, F. Johnson, S. Spraker, M. Briggs, H. Gregg, B. Bramer, V. Sloan, A. Collins, H. Bogart, M. Battenfield, E. Collins, M. Johnson, unidentified, and W. Case; (third row) A. Mitchell, H. Pearson, G. Maloney, E. Louer, ? Van Skiver, N. Timmerman, E. Rogers, A. Hall, L. Faulds, A. Enser, N. Groat, C. Newton, and L. Hoar; (fourth row) T. Keator, E. Foley, W. Cotter, V. Gilpin, M. Farrell, M. Pillig, G. Wilkins, unidentified, W. McCleary, M. Finehout, J. Dynes, J. Smeallie, J. Kennedy, A. Stranberg, E. Davey, L. Fenton, E. Lanfear, R. Webb, T. Hennessy, H. Case, J. Kelly, R. Dunn, and D. Doak. (FMCC-WEM.)

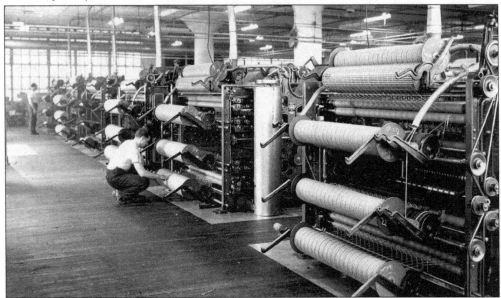

The Sanford family's early participation in the rug industry began an era that catapulted Amsterdam, for a time, into the business world as the nation's carpet capital. Back in the 1870s, Sanford employees were able to produce about 1,000 yards of carpet daily. The age of machinery allowed employees at Bigelow-Sanford, successor to S. Sanford and Sons from a 1929 merger, to produce much greater numbers with the assistance of this 60-inch carding machine in 1941. (FMCC-WEM.)

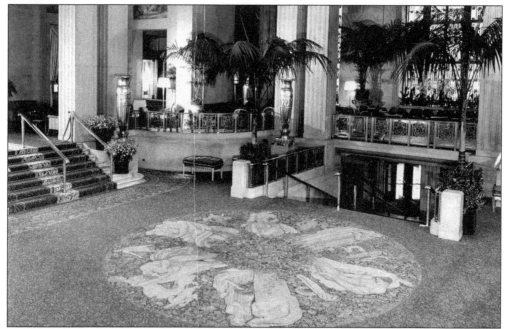

The Mohawk Mills manufactured the Wheel of Life carpet, pictured here in 1940 in the lobby of the Waldorf-Astoria Hotel in New York City in the 1930s. Weighing 850 pounds and measuring 49 feet by 47 feet, the carpet's design expressed the drama of existence from birth to death. Sixteen weavers manufactured the carpet in eight months. (FMCC-WEM.)

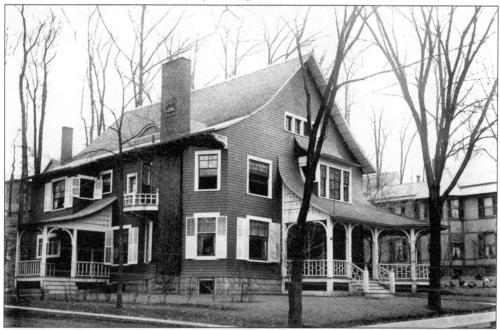

Located at 18 Brookside Avenue, the former W. B. Charles home became a convent for nuns and then was taken over by the exclusive Bigelow Weavers Club in 1933. The weavers were the premier workers in the mills who operated the carpet looms. The club continues to exist today as a private men's organization. (H&A.)

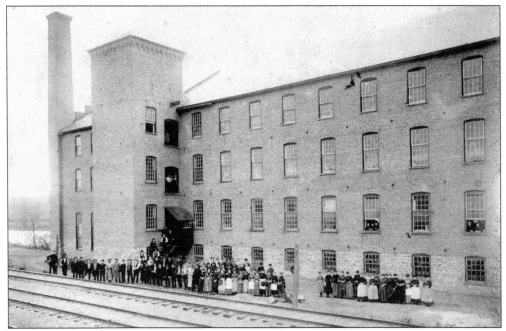

Workers stand in front of the Shuttleworth Carpet Mill around 1895. After a manufacturing start along the Hudson River and death of their father William, the Shuttleworth brothers began carpet production in the then-vacant Kline and Arnold Mill along the bank of the Mohawk River in 1878. (H&A.)

The coming of Herbert L. Shuttleworth as president of the corporation in 1902 and new capital made possible rapid development during the first decade of the century. Several additional buildings appeared on the north side of the railroad opposite the original structure. The Herbert L. Shuttleworth home, pictured here, was located at 321 Guy Park Avenue. (H&A.)

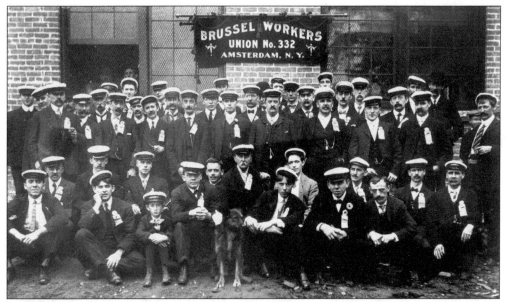

With the expansion of the carpet industry in the 1890s, workers were recruited directly from the English textile industry to manufacturers in Amsterdam. The employees pictured here worked at the Shuttleworth Carpet Mills manufacturing Brussels carpets. (H&A.)

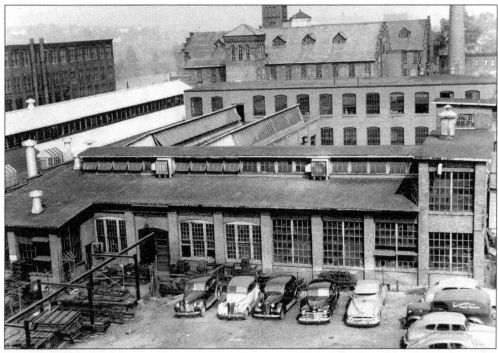

The first large consolidation of the carpet mills was in 1920 when Shuttleworth Brothers and McCleary, Wallin, and Crouse joined under corporate designation as Mohawk Carpets. Mohawk Mills was reorganized into Mohasco in 1955 with the combining of the Mohawk Mills and the Alexander Smith Company of Yonkers. The company ceased operations in Amsterdam in 1968. This photograph shows the lower Mohawk Mills in 1945. (FMCC-WEM.)

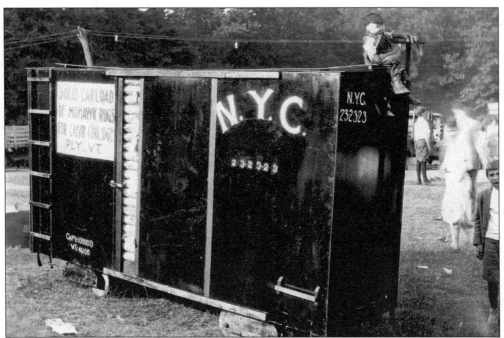

Pictured is a promotional advertisement of "solid carload of Mohawk rugs for Calvin Coolidge, Ply, Vt." in 1927. Coolidge was the 30th president of the United States, 1923–1929. Amsterdam became nationally recognized as a leader in carpet manufacturing in the first part of the 20th century. (FMCC-WEM.)

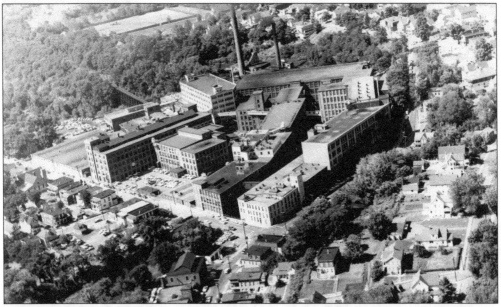

Another company that was to become the third of major Amsterdam floor-covering firms was started about the same time as the Shuttleworth firm. The first effort by partners John Howgate, William McCleary, Samuel Wallin, and David Crouse, all former Sanford employees, was short-lived. Their second effort, shown here on Locust Avenue, was very successful and was later incorporated into the Shuttleworth firm. (H&A.)

Samuel Wallin, two-term mayor of Amsterdam, and a dog stand in front of his carriage house at 162 Locust Avenue. Another start by Wallin, in carpet making, was made in a former shoddy mill along the Chuctanunda Creek in Rockton, and the second effort was highly successful. (H&A.)

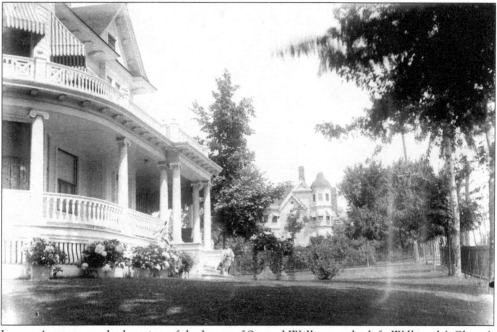

Locust Avenue was the location of the home of Samuel Wallin, on the left. William McCleary's home can be seen in the distance next door. The reorganized McCleary, Wallin, and Crouse built several new buildings, and by 1903, they had tapestry, Brussels and velvet carpets, and rugs in production. (H&A.)

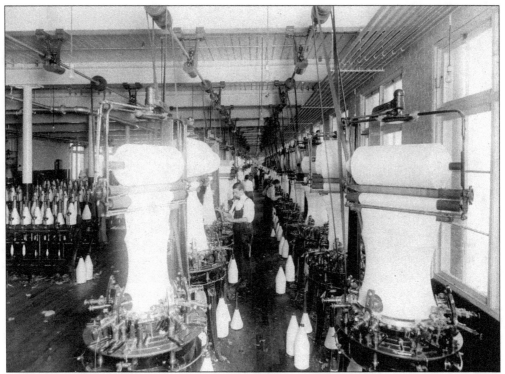

Inside the Chalmers knitting mill, on the south side of the Mohawk River just west of the bridge, this image shows the Porosknit machines. The seven-story structure was home to the manufacture of the seamless underwear, known nationally as Porosknit. (H&A.)

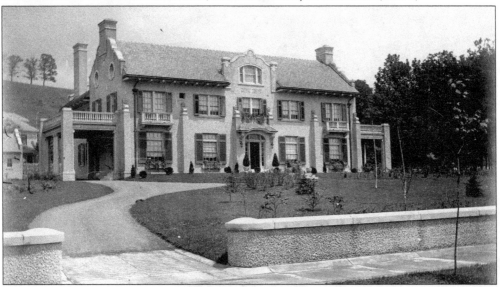

David W. Chalmers was one of four organizers of the 1901 Chalmers Knitting Company. His home is pictured here at 345 Guy Park Avenue. David's father, Harvey Chalmers, ran a hardware store on Main Street as well as a small tool manufacturing business. When that was destroyed by fire in 1898, Harvey's sons, David and Arthur, formed their own companies, David into knitting and Arthur into the Hampshire Pearl Button Company. (H&A.)

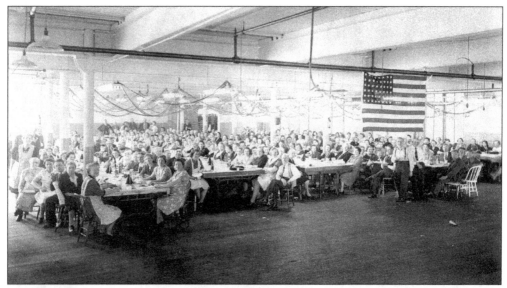

Locally owned manufactories fostered civic pride and a family-like atmosphere among their employees. Pictured here is a 1945 Christmas party for the employees of the Chalmers knitting mill. (FMCC-WEM.)

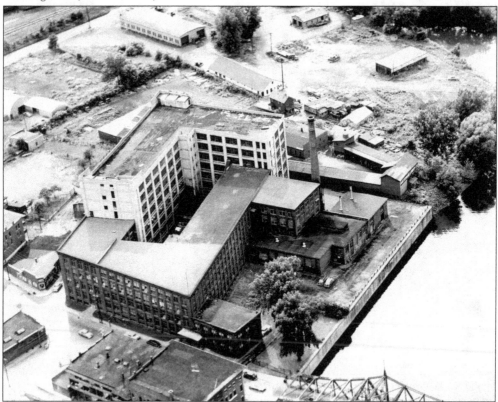

This is an aerial view of the Chalmers knitting factory on the south side in 1959. The seven-story concrete building in the background was constructed in 1913, and in 1916, an adjoining spinning mill was built. (H&A.)

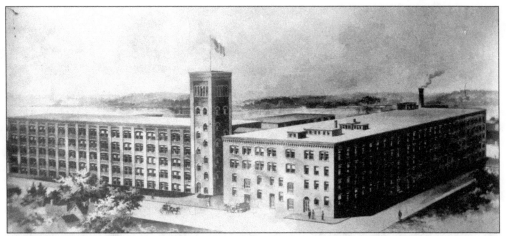

Located on Washington Street, men's long-ribbed underwear was manufactured at the Blood Knitting Mill. The Raphael Waste Company took up residence in this building after the closure of the knitting mill. The building ultimately became a victim of urban renewal. (H&A.)

James Blood, owner of the Blood Knitting Mill and partner in the Chalmers knitting mill, lived here at 267 Guy Park Avenue. Aside from being a successful textile industrialist, Blood also had a hand in the manufacture of brooms. His family established the Pioneer Broom Company. (H&A.)

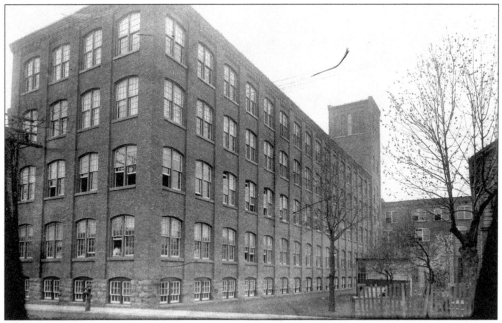

Broomcorn, locally grown on the islands and flats of the Mohawk River, was used in the production of the brooms. The Blood family established Pioneer Broom Company, one of the area's largest broom manufacturers, on Washington Street in 1902. Two years later, the company moved to the six-story building constructed on West Main and Pine Streets. Production continued until the 1930s when use of brooms fell into decline with the invention of the vacuum cleaner. (H&A.)

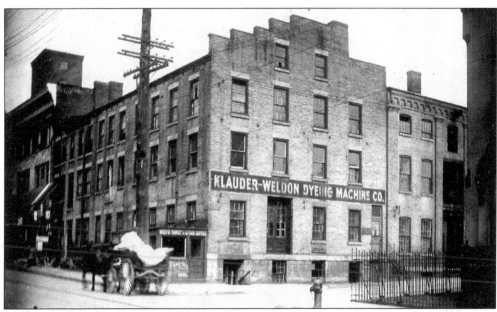

Klauder-Weldon Dyeing Machine Company made machinery for dyeing, bleaching, and scouring. It was the first textile machine builder to introduce machinery to dye raw materials. The company organized in 1892. On the corner of Market and Grove (Livingston) Streets, the site was later used for the construction of the Rialto Theater. (H&A.)

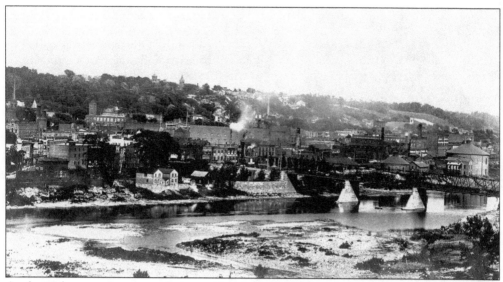

As the 19th century progressed, Amsterdam became the home of many other small industries. This 1905 view of the city from the south side shows the area around the river full of small businesses and manufactories. Hanson and Dickson Furniture is in the center. Becker, Lindsay, and Nolan Shoddy Mill, the Pioneer Knitting Mill, and the W. H. C. McElwain Foundry and Machine Shop can all be seen in from this view. (H&A.)

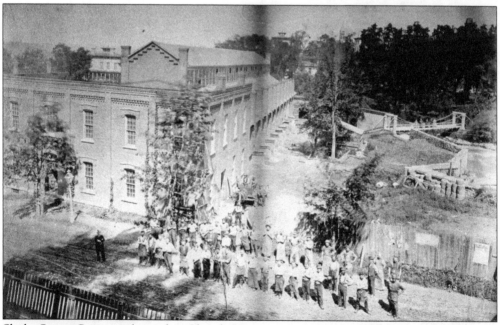

Shuler Spring Company, located on Church Street, opposite the present city hall in 1856, became the largest maker of elliptical springs for carriages, wagons, and seats. By 1869, Davis W. Shuler's employees manufactured approximately $200,000 worth of carriage springs. The buildings were taken over by S. Sanford and Sons around 1910. Shuler lived in a large home overlooking his factory. The home's site is now the location of Fiber Glass Industries. (OFJ.)

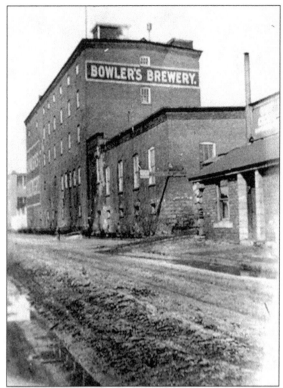

Located on West Main Street, Bowler's Brewery, shown here around the end of the 19th century, was started by Harry F. Bowler near a spring in 1889 and was rebuilt after a fire in 1895. The brewery produced upward of 50,000 barrels a year of malt beverages. The company went out of business in the mid-1930s due to Prohibition restrictions. All Seasons Equipment Company now occupies the building. (FMCC-WEM.)

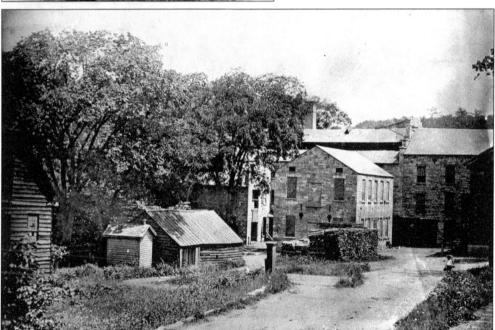

The Kellogg and Miller factory got its start in West Galway in 1824. Moving operations to Amsterdam in 1851 at Church and Cornell Streets, the factory produced up to 6,000 gallons of linseed oil by the end of the 19th century. Pressing seeds from the flax plant, linseed oil is primarily used in paint thinners and industrial cleaners. Portions of the buildings remain. (H&A.)

The early Italianate Victorian home of balloon construction was built in 1858 for industrialist John Kellogg, owner of Kellogg and Miller, a large linseed oil business in Amsterdam. A fine example of neoclassical architecture of its time, the Kellogg Mansion is today home to the law offices of Sise and Sise. It is located on Church Street next to the former Sanford Mansion, today's city hall. (H&A.)

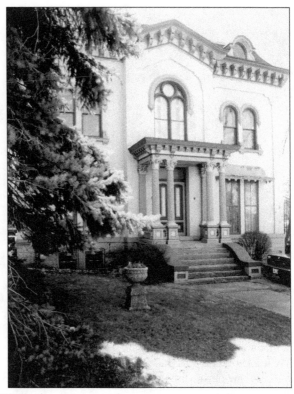

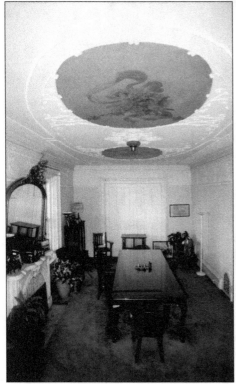

The brick-faced structure has all the original hardware and trimmings, including six marble fireplaces. Elaborate raised rococo plaster moldings surround two decorative ceiling murals of cherubs, flowers, birds, and flowing ribbons. The geometric lines and flowing shapes in the moldings and light fixtures tie the walls and ceilings together, creating a warm and harmonious atmosphere. (H&A.)

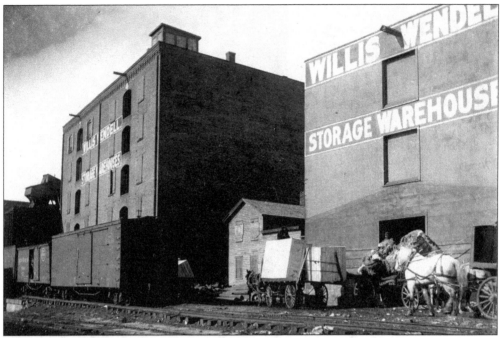

Willis Wendell, resident of Church Street, operated his storage warehouses on Hamilton Street. Their location next to the railroad tracks made for ideal shipping for refrigerated goods. Wendell was also one of the directors of the Amsterdam Street Railroad Company. (H&A.)

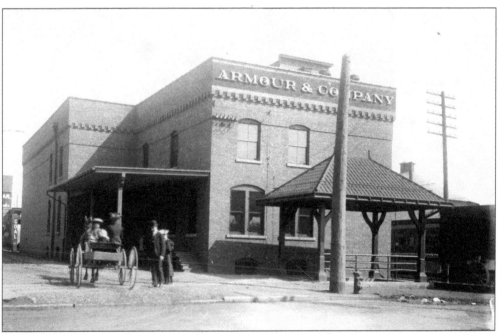

Armour and Company, on the corner of Railroad and Voorhees Streets, produced wholesale processed meats. It was built in 1904. When a new station was built in Amsterdam in 1895, a subway was constructed under the tracks to the new passenger station, and the subway's entrance can be seen in front of the Armour and Company building. (H&A.)

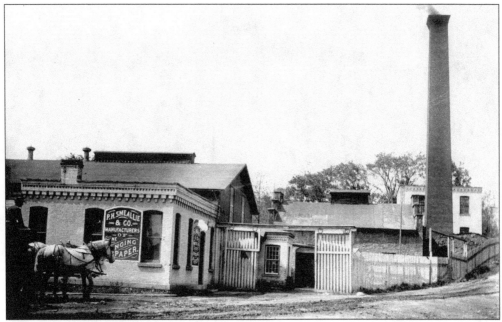

The manufacture of straw wrapping paper began on Forest Avenue in 1866 by the firm of Stewart and Carmichael, making the change to brown hanging paper then to blank white wallpaper in 1874. The firm was succeeded by P. H. Smeallie and Company, which by 1914 was making paper boxboard. (H&A.)

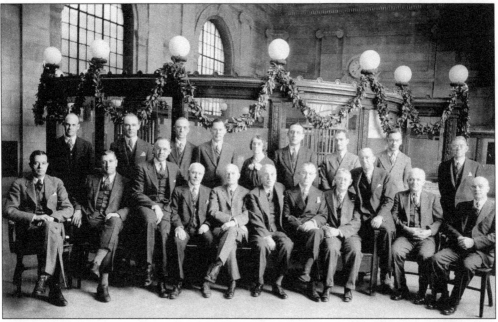

Amsterdam Savings Bank, shown here in 1936, opened in 1887 in the Simpson Block at 25 Market Street. In 1913, the banking firm moved to Division Street. Due to the growth in assets, criticisms were heard that the assets were out of proportion with the income in Amsterdam. This was the only banking institution created in the 19th century that held off a series of mergers and kept its local authority until the late 20th century. (FMCC-WEM.)

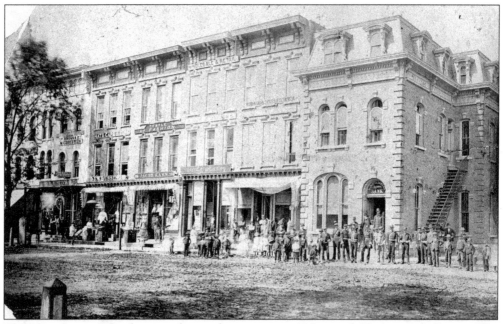

The Manufacturer's Bank sat on the northwest corner of Main and Chuctanunda Streets. The bank was organized in 1873 as a state bank where Adam W. Kline served as the first president and Charles DeWolfe as cashier. Two years later, it was reorganized as a national bank only to dissolve in 1883. Note the many businesses in the three-story buildings to the left and the 13th Brigade Band outside of the bank building. (OFJ.)

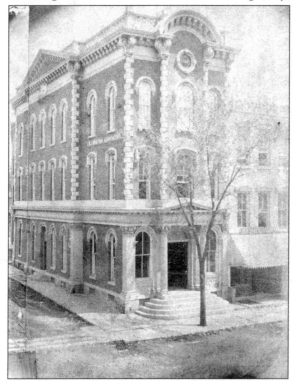

At the northeast corner of Main and Chuctanunda Streets sat the First National Bank building, constructed in 1866. First organized in 1860 as the Bank of Amsterdam, the institution received its national charter in 1865 and was renamed the First National Bank. In this photograph, the YMCA occupies the building's upper floors. In 1929, the bank moved to a new seven-story building across East Main Street. (OFJ.)

William Shuler, left, and Dave
Manny, third from left, stand
in front of Snook and Manny's
Retail Liquor Store, 52 East
Main Street, in the early 1880s.
Shuler was the son and partner
of Davis W. Shuler at Shuler's
Spring Shop. In 1889, Dave
Manny was the proprietor of
the Manny House Hotel. (OFJ.)

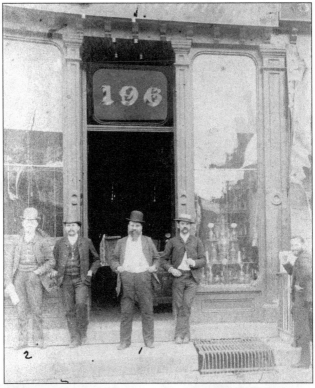

Four men stand in front of a barbershop on East Main Street in the early 1900s. There is an
advertisement for McCaffrey Brothers Real Estate and Insurance on the building in the back.
McCaffrey Brothers was located at 56 East Main Street in 1907. (H&A.)

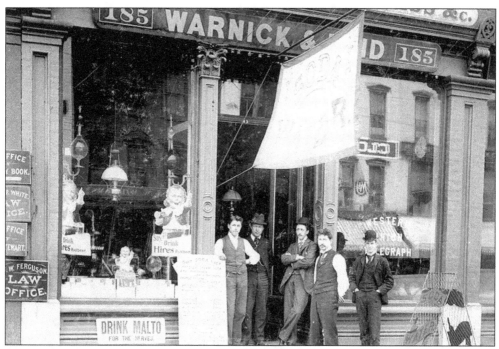

Pictured from left to right are H. Putman, M. Brooks, a Mr. Frazier, W. Reid, and J. Clements in front of Warnick and Reid. This store, located at 185 Main Street, was a pharmacy also selling paints and oils in 1875. M. W. Reid also ran a Western Union Telegraph at this site. (FMCC-WEM.)

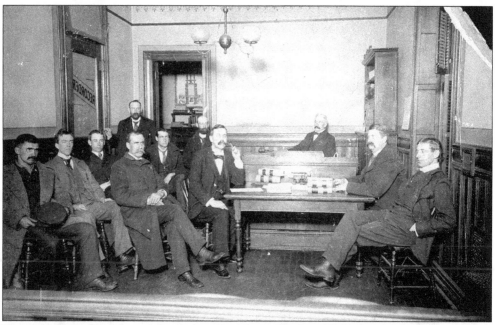

The *Amsterdam Recorder* was located in the Morris Block at 27–31 East Main Street, moving there in 1886. The city's first daily newspaper was published in 1879. By 1893, the *Evening Recorder* merged with the *Daily Democrat* under the direction of William J. Kline. Pictured here is the newspaper's office group in 1890. (FMCC-WEM.)

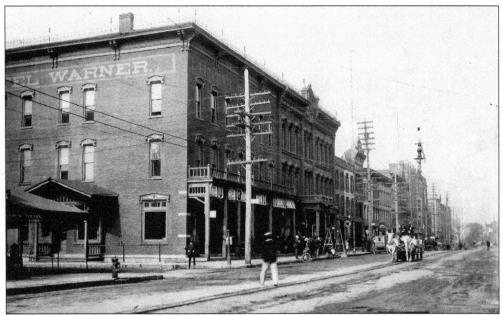

In 1880, Amsterdam's first large hotel, the Hotel Warner, opened on the corner of Walnut Street and East Main Street. The four-story hotel provided travelers with luxurious lodging in 76 spacious rooms equipped with telephones and electric lighting. This photograph, from the late 1890s, shows the business district here on East Main that also includes the McDonnell Hotel and Holzheimer and Shaul's clothing store. (H&A.)

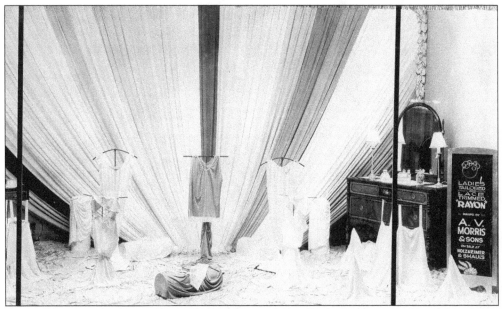

Pictured here is a display window at Holzheimer and Shaul's clothing store on East Main Street featuring the products of A. V. Morris and Sons knitting mill, which started in 1881. The mill was located on Chuctanunda Street. (Jonathan Hubbs.)

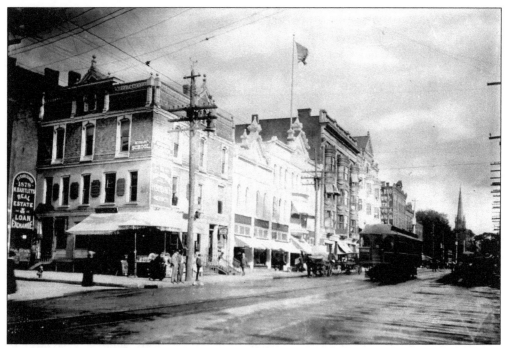

East Main Street at the corner of Church Street shows the first location of Reynolds Business School, above the post office. R. E. Lee Reynolds, a lawyer and teacher at the Amsterdam Academy, ran the school. In the distance can be seen the Cassidy Buildings Nos. 1 and 2. (H&A.)

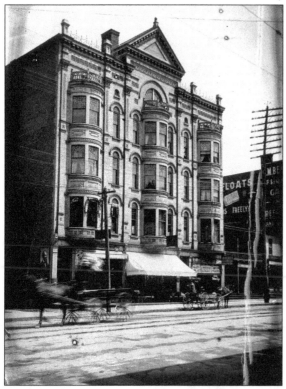

Cassidy Building No. 1, at 78–82 East Main Street, was designed by architect David D. Cassidy Jr. The building, of intricate design, housed the grocery store of Newburger Brothers, Isaac and Jacob, as well as apartments on the upper floors. (H&A.)

Peter J. Collins's home, at 96 West Main Street and the foot of Mohawk Street, overlooked the Mohawk River. Collins was a freight agent for the West Shore Railroad, which ran on the south side of the river. The freight station was originally located in Port Jackson, the area later known as South Amsterdam. (H&A.)

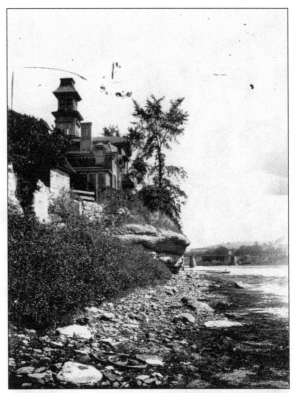

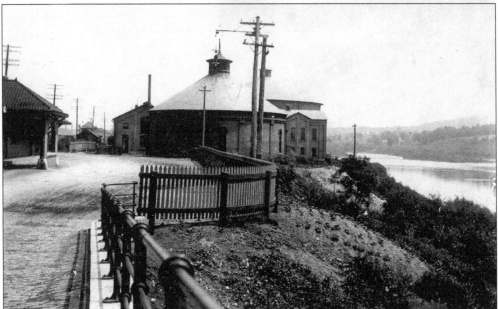

The Chuctanunda Gas Light Company was organized in 1860. The original plant was destroyed by fire in 1866, and after rebuilding in 1867, the company began using coal for gas production. The plant, pictured here around 1890, was located behind the railroad station that is now just east of the present Route 30 bridge. Expansion came in 1876, and the company was purchased by the New York Power and Light Company in 1929. (H&A.)

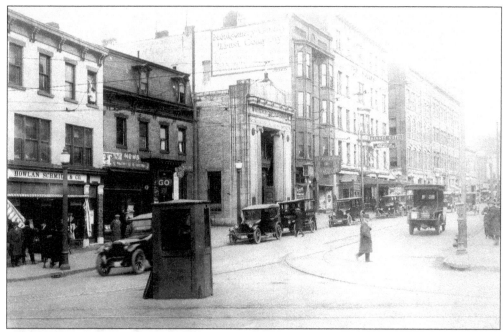

This view is looking north up Market Street at the corner of Main Street about 1920. The structure in the center of the street is the kiosk for the traffic policeman. There were numerous trolley car accidents at this junction from cars skidding down Market Hill during the winter. (FMCC-FJ&G.)

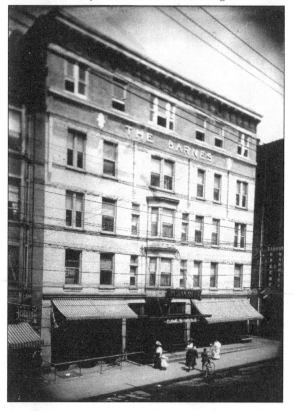

The Barnes Hotel, successor to Kurlbaum's Central Hotel, came to Market Street in 1910. The hotel got its name from proprietor John Barnes, the knit goods manufacturer. Its size rivaled the Hotel Warner. (H&A.)

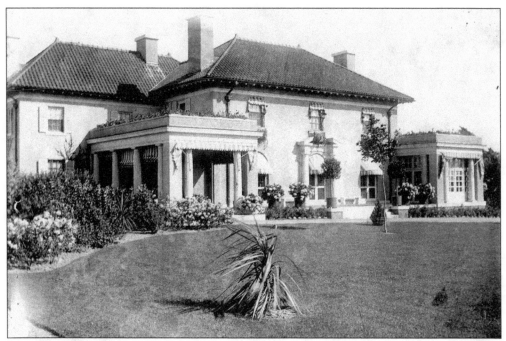

John Barnes's home at 245 Market Street was one of Amsterdam's most palatial residences. Barnes, in addition to being a textile manufacturer as a partner in the Blood Knitting Company, founded the Montgomery County Trust Company. (H&A.)

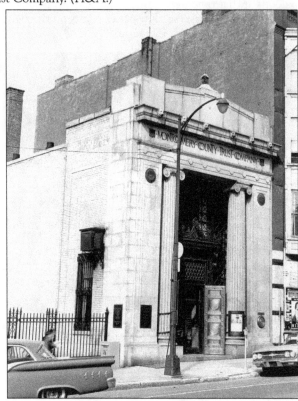

In 1912, founders of the Montgomery County Trust Company included John Barnes, the Blood brothers, Solomon Holzheimer, William J. Kline, William McCleary, Spencer K. Warnick, and the Yund brothers. The building pictured here in 1965 was the second home of the bank, which opened in December 1913. (OFJ.)

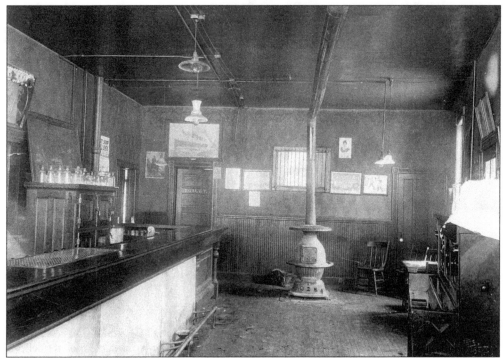

The home of Flanagan's Saloon was located at 161 Church Street, near the Sanford mills. Saloons at that time were limited to male patronage, evidenced by the single restroom and the spittoons beneath the bar. The player piano, on the right, was the newfangled entertainment in the first decades of the 20th century. (H&A.)

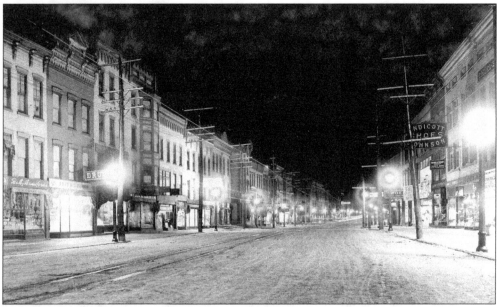

Lampposts with underground wiring illuminated Amsterdam's streets and storefronts beginning in 1916. This winter scene shows downtown Amsterdam at the corner of Market and East Main Streets, looking east toward Chuctanunda and Church Streets around 1920. (FMCC-WEM.)

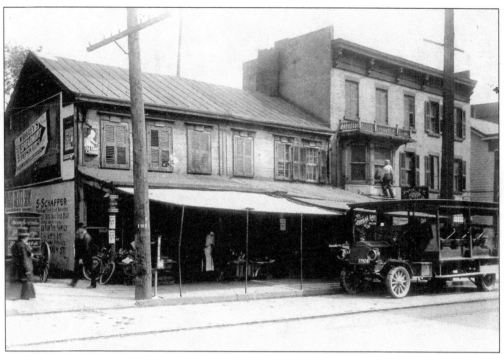

At 19–23 Market Street, the Central Café, on the right, was a saloon run by Charles Gray in 1913. Next door is W. A. Fuller's grocery store, an example of Amsterdam's early-19th-century homes that were transformed for commercial use. (H&A.)

The Amsterdam Hygeia Ice Company truck delivers ice on Market Street near Summit Avenue around 1910. The ice company, incorporated in 1907, harvested ice at the city reservoir, built by John Sanford in 1844. Delivering to residents all over the city, the officers of the Amsterdam Hygeia Ice Company at the time of incorporation were Edward J. Shanahan, James W. Ferguson, Spencer K. Warnick, and Henry E. Greene. (FMCC-WEM.)

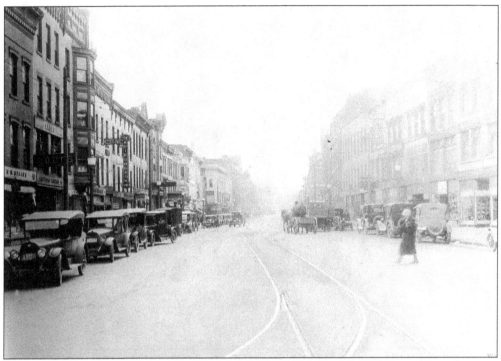

Looking west on Main Street at the corner of Market Street around 1920, one can see the great variety of downtown businesses that once added to Amsterdam's prosperity. (FMCC-FJ&G.)

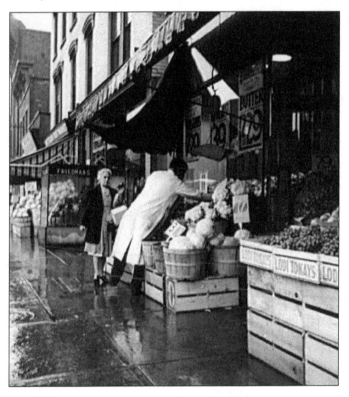

This October 1941 view showing 117–125 East Main Street was the home of Karuza's Pharmacy, Charles B. Friedman's Clothiers, and the Mohican Company Grocers. (Library of Congress, Prints and Photographs Division, FSA-OWI Collection, [reproduction number, LC-USF34-081263-E DLC].)

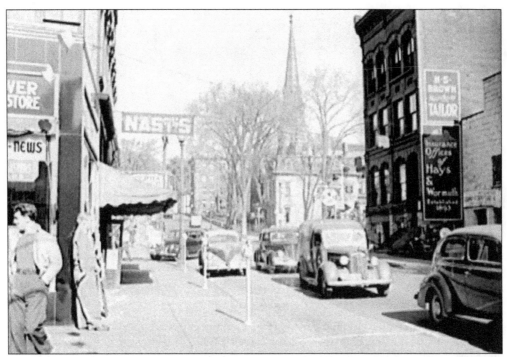

Nast's Cut Rate secondhand store at 6 Church Street on the left is now the law offices of Richard T. Horigan. Across the street, the building housing Hays and Wormuth Insurance Agency was razed during the period of urban renewal and is now the site of the Riverfront Center. This 1941 photograph shows the Second Presbyterian Church. (Library of Congress, Prints and Photographs Division, F SA-OWI Collection, [reproduction number, LC-USF34-081496-E DLC].)

Local boxer "Pinky" Palmer owned the Crown Cigar Store and News, on East Main Street. The White Tower restaurant, seen here in October 1941 on the corner of Church and East Main Streets, sold hamburgers for 10¢ each. (Library of Congress, Prints and Photographs Division, FSA-OWI Collection, [reproduction number, LC-USF34-081497-E DLC].)

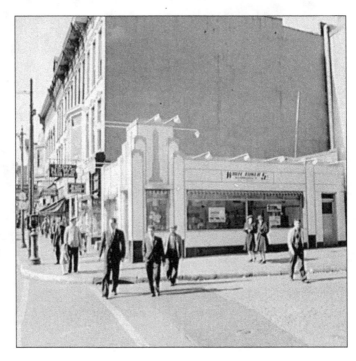

The homes of Dr. Charles McClumpha and H. H. C. Bingham were located at 56 and 58 Church Street. McClumpha, whose ancestor John H. started McClumpha's Grocery at the corner of Main and Market Streets, was a professor of English for many years at the University of Minnesota. He returned to Amsterdam to become one of the founding members of the Montgomery County Historical Society in 1904. The McClumpha home is now the headquarters of the Polish American Veterans, Inc. (H&A.)

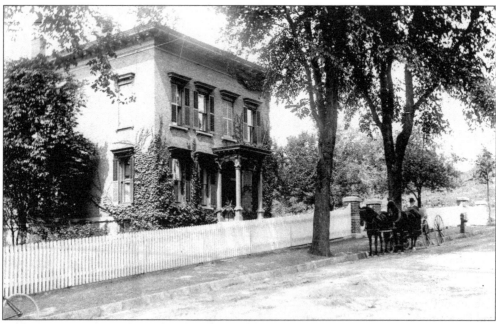

Fred Davey, proprietor of a coal and storage business on Hamilton Street, owned this home on Brandt Place, pictured here in 1910. The old Amsterdam High School was located just beyond this house to the right. (H&A.)

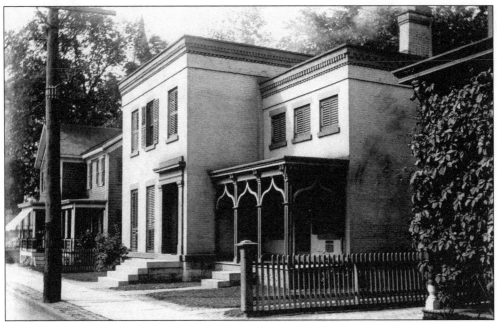

Dr. Charles F. Stover, physician, made his home and office at 31 Division Street, also known as "Doctors Row" for the number of doctors' offices located there. Stover served as the president of the Montgomery County Medical Society in 1890 and was also a founding member of the Montgomery County Historical Society when it formed in 1904 at the public library. (H&A.)

Pictured here is the home of Dr. Richard Johnson (1907), Dr. Archibald Gilbert (1915), and St. Anne's parsonage at 35 East Division Street. Johnson was known for his generosity and compassion when he cared for some of the residents of the Sarah Jane Sanford Home for Elderly Women free of charge. In 1923, the parsonage of the St. Anne's Episcopal Church was constructed on this site. (H&A.)

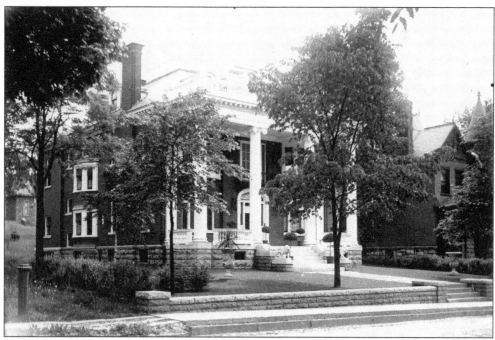

Theodore J. Yund, owner of Yund, Kennedy, and Yund Knit Goods Manufacturing, resided in this extravagant home at 125 Guy Park Avenue at the foot of Eagle Street in 1913. The garage was one of the few in Amsterdam to have a turntable that allowed the residents to enter and leave the drive without having to back out. Yund, Kennedy, and Yund organized in 1886, as makers of fancy light and heavy knit underwear, and the company had flourished by 1902. (H&A.)

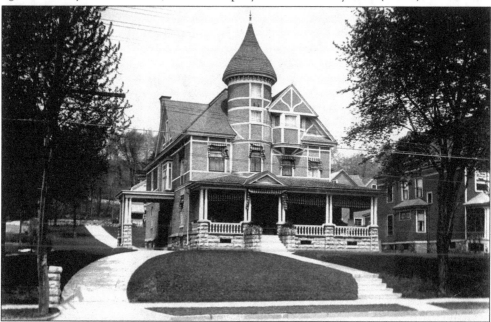

Spring Street, which later became Guy Park Avenue, was once known as "Millionaire's Row" because of the numerous substantial homes that were built by the wealthy businessmen of Amsterdam. Pictured here is the home of tea broker George H. Maus at 295 Guy Park. (H&A.)

Three

CIVIC LIFE AND GOVERNMENT

The Amsterdam Board of Trade, pictured here in 1917, was the predecessor to the chamber of commerce. Created in November 1884 for the purpose of advancing the village's best interests, the board of trade first met in the insurance building on Church Street before making its home here in the Sanford Homestead building on Market Street. Police headquarters and the city's common council were headquartered in this building until removal of both in the early 1920s. (H&A.)

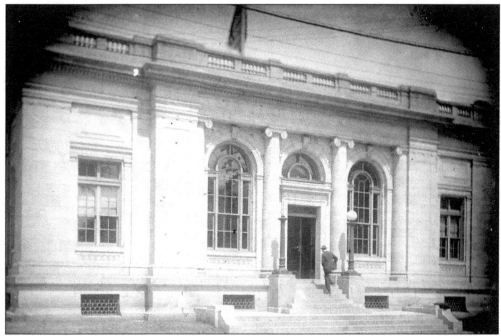

Amsterdam's first federal building, seen here, was the U.S. post office constructed at the corner of Division and Wall Streets in 1912. The post office had moved to this location from the Sugden Block on Market Street (former site of Benedict Arnold home) in hopes that the growth of the city would progress in that direction. The building, with the adjacent Independent Order of Odd Fellows (IOOF) hall and neighboring 1904 high school, was razed in 1979. (H&A.)

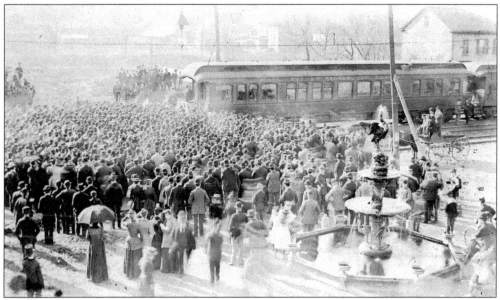

In 1896, William McKinley made a stop in Amsterdam during his campaign for the U.S. presidency. William J. Bryan was another notable politician who made a stop in Amsterdam for the same purpose in an unsuccessful campaign. Stephen Sanford purchased the ornate water fountain that sat at the railroad station until it was moved to the St. Mary's Catholic Church complex. (OFJ.)

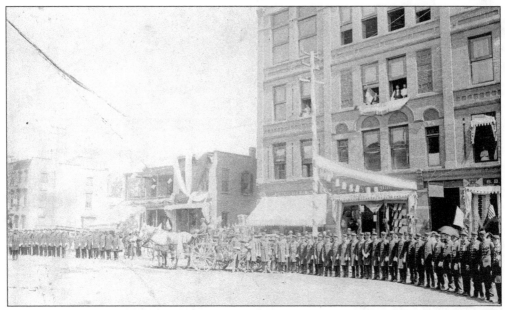

In 1839, the community of Amsterdam purchased its first fire engine, which was housed in the J. D. Serviss Steamer and Hose Company building on Chuctanunda Street. The first method of fire protection was with "the tub," which had a very short range and could only contain very small fires. Every household was required to have leather buckets, depending on the size of the building, and family members assisted in fighting the blaze. The department is pictured in front of Barnett Brothers at 71 East Main Street. (H&A.)

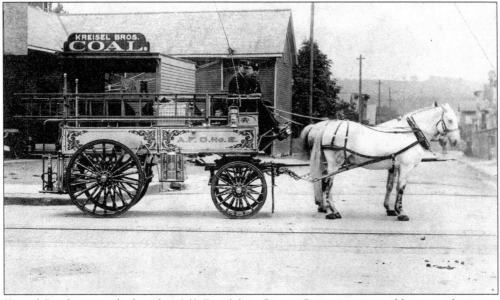

Kreisel Brothers supplied coal at 263 East Main Street. Customers were able to purchase one bushel of coal at a time. The E. D. Bronson Fire Company No. 2 was formed in 1871. The volunteer company firehouse was located on Market Street. In addition to using the ladder truck, seen here around 1917, the horse-drawn steam-pressure engine was a progressive, albeit slow, measure in the fight against fires. (H&A.)

John Callahan served as a fireman in the Amsterdam Fire Department on Reid Street in Company No. 3. He retired from the fire department in the 1940s. His funeral, pictured here in the early 1950s, took place at St. Mary's Church on East Main Street. (H&A.)

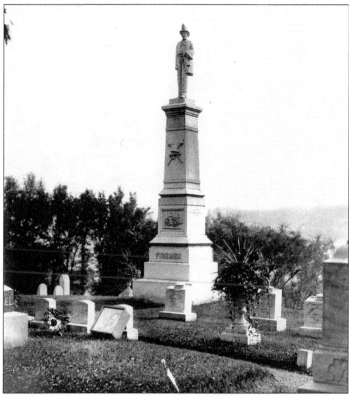

This monument was placed at Green Hill Cemetery honoring the community's firemen. At some unknown date and by an unknown authority, the monument was dismantled. The figure atop the monument was taken down and now stands as a memorial at the Fort Johnson Firehouse. In April 1907, fireman William Sullivan was killed when a wall collapsed during a blaze at the Amsterdam Broom Company on Brookside Avenue. (H&A.)

The doors of St. Mary's Hospital were first opened in the former Abram Marcellus home, on Upper Guy Park Avenue, in 1903 by the Sisters of St. Joseph of Carondelet. The nurses' quarters, seen here in this 1917 photograph, was on Guy Park Avenue. A nursing school opened in 1921 after a request came from the state to provide training for nurses. The Marcellus home was demolished in 1980 to make room for a modern four-story addition to the hospital. (FMCC-WEM.)

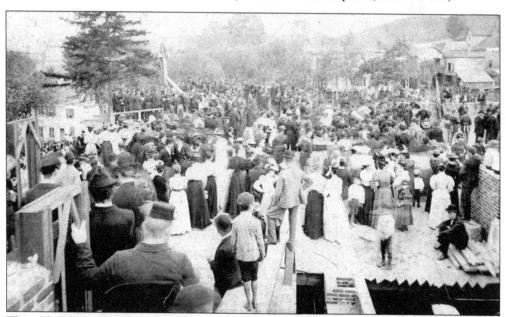

The 46th Separate Company became part of the New York State National Guard on September 3, 1888, promoting the state's military program. The state then mandated the county to provide a location for drilling of this unit. Drills for training the local National Guard unit were held on the top floor of the Behr Block on Main Street. The cost was $700 annually, considerably less than the $45,000 total cost to build the armory, an expenditure mandated by the state legislature and provided for by the taxpayers of Montgomery County. The laying of the cornerstone of the armory is seen here in September 1894. (OFJ.)

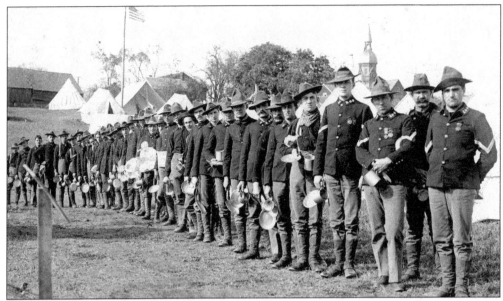

The local unit of the National Guard, originally known as the 46th Separate Company, was deployed from Amsterdam at the beginning of the Spanish-American War when it was redesignated Company H, 2nd New York Volunteer Regiment. It left Amsterdam on May 2, 1898, from the new railroad station and headed toward Camp Black on Long Island, where they would be stationed for two weeks. (Diane Smith.)

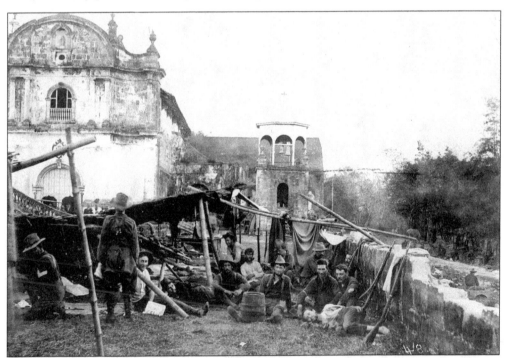

Company H, 2nd New York Volunteer Regiment returned from the Spanish-American War in late August 1898 to Averill Park down by Albany, where they mustered out on November 1. Here the unit is in Paete Church, Luzon, Philippines. (Diane Smith.)

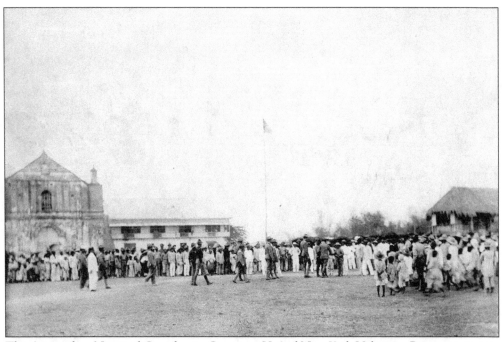

The Amsterdam National Guard unit, Company H, 2nd New York Volunteer Regiment, is seen in this photograph at Paete Church, Luzon, Philippines, on duty in 1898. (Diane Smith.)

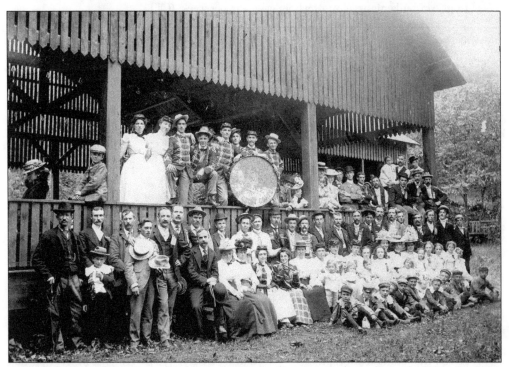

Spanish-American War veterans have a picnic at Crescent Park in the early 1900s. In 1904, the veterans became known as the Stephen Sanford Camp No. 6. The last surviving veteran in Amsterdam was Charles J. Schwartz, who was still living in 1974. (FMCC-WEM.)

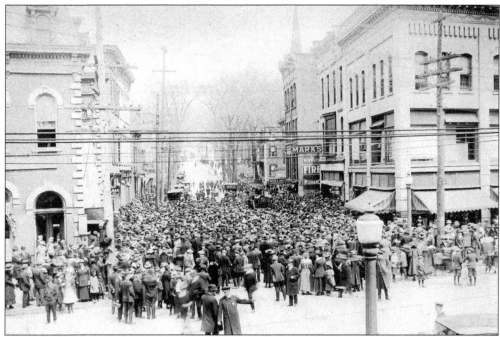

In 1918, a drive was held selling war bonds at Main and Chuctanunda Streets. These drives were accompanied by parades and vocal concerts. Almost $400,000 was raised by the end of World War I from Amsterdamians, most of whom gave 25¢ per week. (OFJ.)

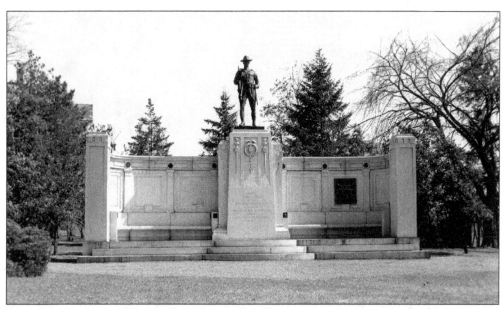

Part of the funds raised from selling Liberty Bonds went toward putting up this $35,000 stone monument honoring the soldiers of the armed forces. Erected in 1923 in West End Park on West Main Street, the monument originally included a Big Bertha–type German cannon that had been captured during World War I. A park at the east end of the city was named Coessens Park, commemorating the sacrifice of Matthew J. Coessens, the first Amsterdam resident who gave his life for his country in World War I. (FMCC-WEM.)

60

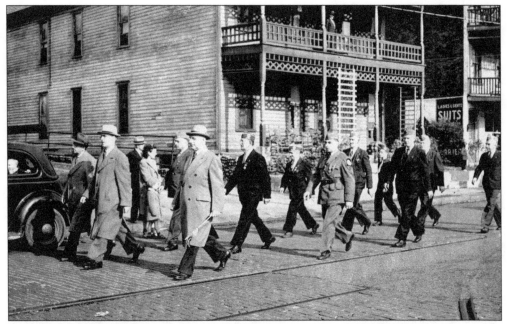

Robb DeGraff, Walter Young, and Carl Salmon are among those in the parade during an event in which the Sixth Ward service flag was dedicated on October 18, 1942. An honor roll of the men and women serving in the armed forces was erected at the Sixth Ward's No. 5 Fire Station at 327½ Division Street. (H&A.)

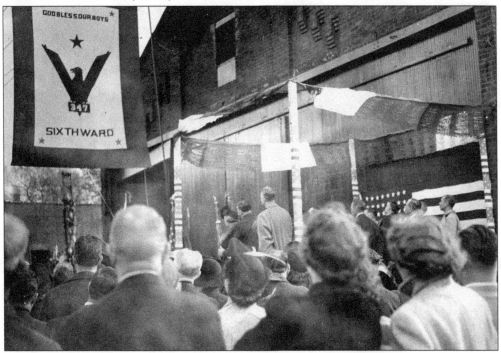

Another scene from the dedication of the Sixth Ward service flag on October 18, 1942, appears here. The first soldiers to enter World War II from Amsterdam were 15 individuals who departed on November 27, 1940. (H&A.)

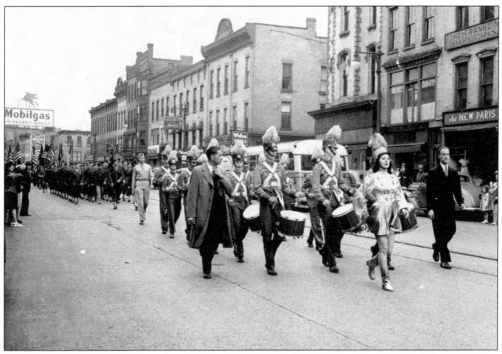

A parade, such as the one seen here in the 1940s, was held on September 15, 1945, for VJ Day in Amsterdam, and the theme was "Massed American Colors." (St. Mary's Catholic Church.)

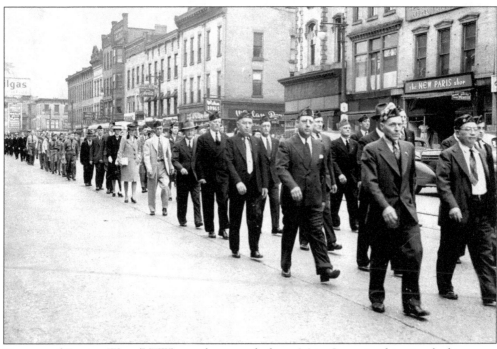

Veterans of Foreign Wars (VFW) members march down Main Street in this view looking west during the same parade in the 1940s. At that time, the New Paris Shop was located on the north side of the street, nearly across from its south side location today. (St. Mary's Catholic Church.)

Four

ROADS, BRIDGES, AND TRANSPORTATION

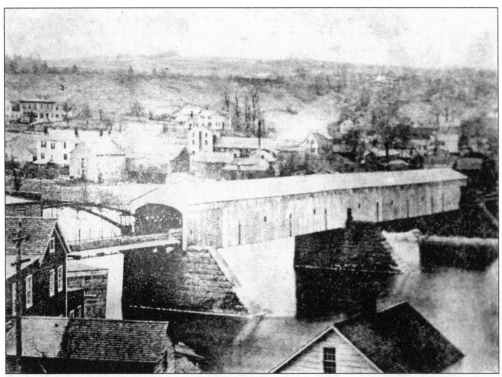

The first bridge spanning the Mohawk River from Amsterdam to Port Jackson on the south side was constructed in 1821 having two spans sharing a pier. Two more bridges were built in 1839, and then in 1842, this wooden bridge, constructed by William L. Shuler and William T. Sammons, part of which was carried away by a canal boat and high water in 1865. (H&A.)

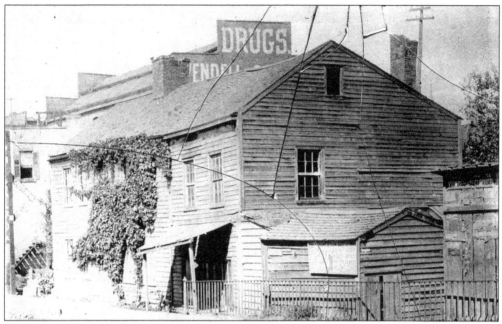

The tollgate house at the bridge crossing the Mohawk River was constructed at the same time as the 1821 bridge. Previous to the 1821 span, the only way to cross the Mohawk River was by ferry or skiff. Amsterdam's first burying ground was located on the banks of the Mohawk just west of the tollgate. The Utica and Schenectady Railroad, when it opened in 1836, passed through the north side of the graveyard. (OFJ.)

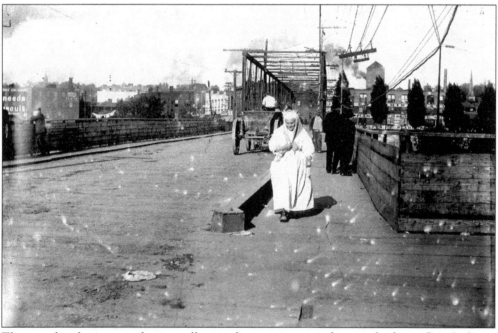

The state legislature passed an act allowing free passage over the river bridge to Port Jackson, previously a toll bridge owned and maintained by a group of stockholders in 1864, to travelers such as the woman in this late-19th-century photograph. (H&A.)

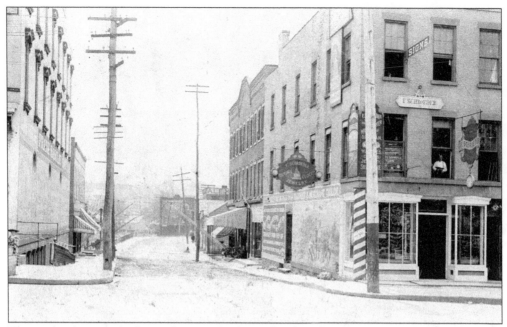

This early photograph shows the river bridge and Schroeder's Jewelry on West Main Street, taken on July 27, 1894. Bridge Street was one of the first streets to be paved with bricks in Amsterdam in 1896. West Main Street received pavement around 1911. (H&A.)

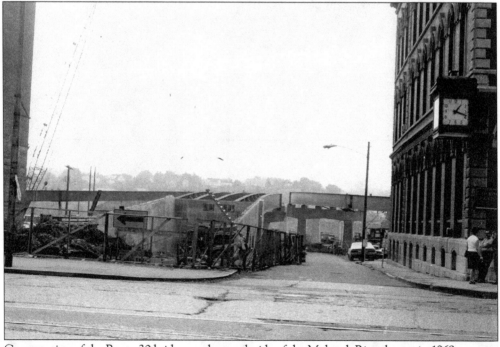

Construction of the Route 30 bridge on the north side of the Mohawk River began in 1969 as a part of an arterialization program that modernized the city over the course of 20 years. This new bridge, east of the 1916 river span, passed over the tracks of the Penn-Central Railroad coming out onto Church Street. Dedication of the five-lane bridge came four years later, in 1973. (FMCC-WEM.)

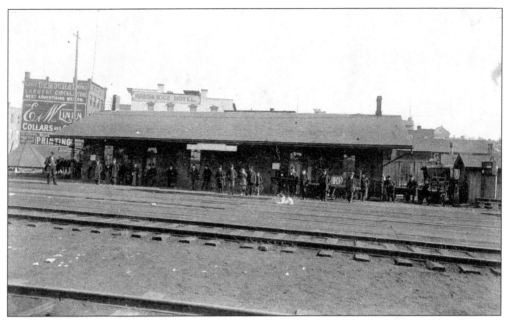

The first passenger depot was built in 1867 at the foot of Railroad Street. At the end of the 19th century, another larger depot, shown here in 1899, was erected on the south side of the tracks with an overhead traffic crossing at the level of the river bridge completed in 1895. The freight house, at the foot of Hamilton Street, was expanded during the first decade of the 20th century at a cost of $1 million. (FMCC-WEM.)

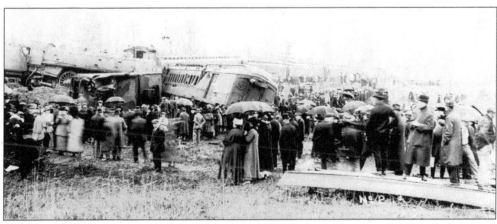

The Empire State Express, known for its high speeds, carried passengers on the New York Central Railroad (NYCRR). In April 1918, the express crashed into a freight train near Henrietta Street. Two passengers were killed and many injured. (OFJ.)

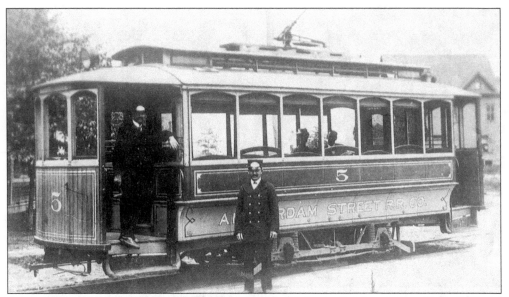

An early car on the Amsterdam and Rockton Street Railway, this Amsterdam Street Railroad car No. 5 was built by Lamorin Manufacturing in 1892. The Amsterdam Street Railroad Company was absorbed by the Fonda, Johnstown, and Gloversville Railroad (FJ&G) in 1901, about 28 years after its initial opening. (FMCC-FJ&G.)

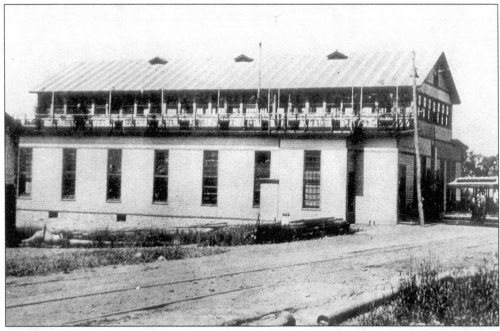

The Amsterdam Street Railroad Company carbarn was located at the corner of Division and Henrietta Streets in the 1890s. The upper floor housed a dance hall with an open porch along one side. (FMCC-FJ&G.)

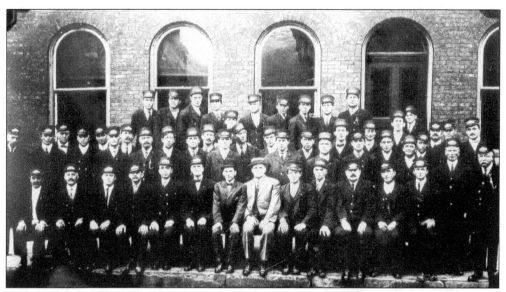

Crewmen at the Amsterdam power plant of FJ&G pose for this photograph on Walnut Street about 1900. (FMCC-FJ&G.)

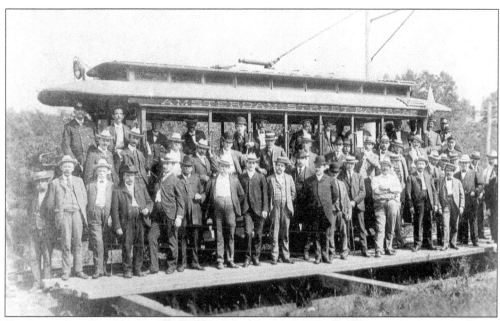

On September 25, 1902, an FJ&G locomotive hauling a platform car made the first run on the line from Johnstown to Amsterdam and Schenectady. This photograph shows the officers gathered for the opening of the regular electric service in 1903. (FMCC-FJ&G.)

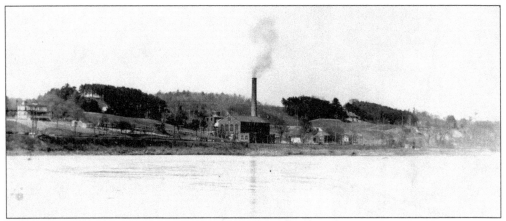

This photograph shows Mohawk Drive in Tribes Hill, formerly the main route known as the Mohawk Turnpike, later becoming New York State Route 5. With the 1958 completion of a new thoroughfare north of Tribes Hill, traffic on the new Route 5 bypassed the hamlet. The 1962 renovations to Route 5 in Fort Johnson made use of the old FJ&G tracks. The FJ&G power plant, seen here, was located on Mohawk Drive at the eastern end of Tribes Hill. (H&A.)

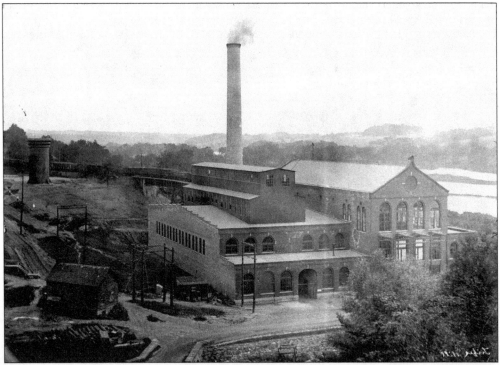

FJ&G constructed a steam-driven power plant in the west end of the hamlet of Tribes Hill to supply electricity necessary for the extensive trolley lines. The plant provided 13,000 volts—25 cycle currents to three substations in Amsterdam, Glenville, and Johnstown. Electric power was also supplied for residents of the city of Amsterdam. After the abandonment of electric trolley service on June 29, 1938, the power plant was taken down. (H&A.)

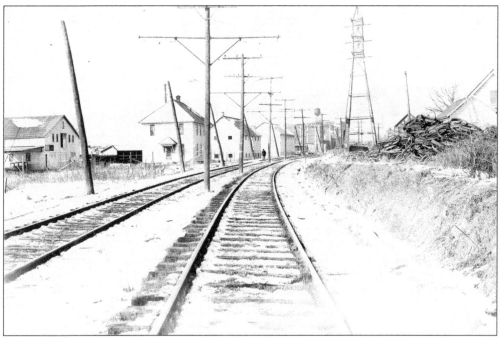

This 1932 photograph shows the FJ&G tracks east of Amsterdam. On July 1, 1903, FJ&G opened a high-speed double-track line to Schenectady, mostly paralleling the NYCRR tracks. For many years, FJ&G tickets could also be used on NYCRR trains going from Amsterdam to Schenectady. (H&A.)

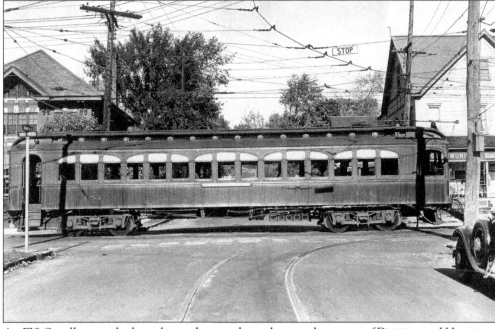

An FJ&G trolley travels along the tracks near the carbarn at the corner of Division and Henrietta Streets around 1931. There were four tracks in the carbarn, two of which had pits underneath for maintenance and repairs. (H&A.)

A barge enters Lock 11 at Guy Park Manor in 1941. The New York State Barge Canal officially opened for traffic on May 15, 1918 with three locks in the Amsterdam vicinity, beginning with Cranesville. (Library of Congress, Prints and Photographs Division, FSA-OWI Collection, [reproduction number, LC-USF34-018526-E DLC].)

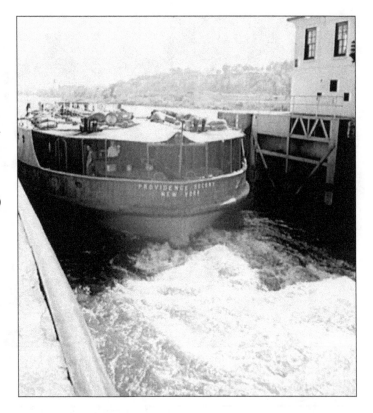

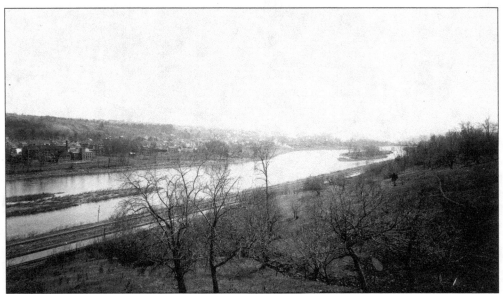

This view of Amsterdam shows four modes of transportation, the Mohawk Turnpike (north of the river), the Mohawk River, the tracks of the West Shore Railroad to the river's south, and the Erie Canal. (H&A.)

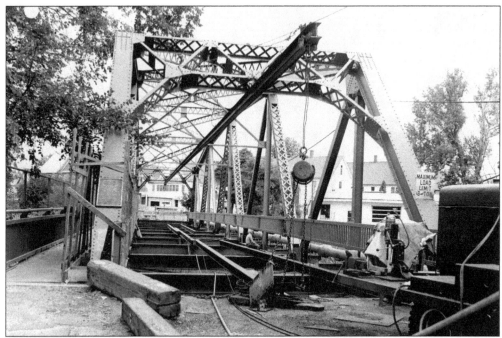

Amsterdam's growth prompted the building of many bridges linking various portions of the city with spans across the Chuctanunda Creek. This bridge on Pulaski Street required rehabilitation in 1978. (H&A.)

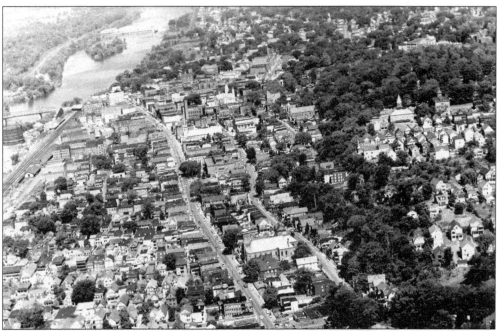

This aerial view of the city, taken from the east, shows the downtown business section of Amsterdam in 1959 prior to urban renewal. From rerouting traffic for the new arterial highways to modernizing the city's commercial district with a shopping mall, 125-room hotel, and business plazas, more than 100 19th-century buildings fell victim to demolition. (H&A.)

Five

CHURCHES

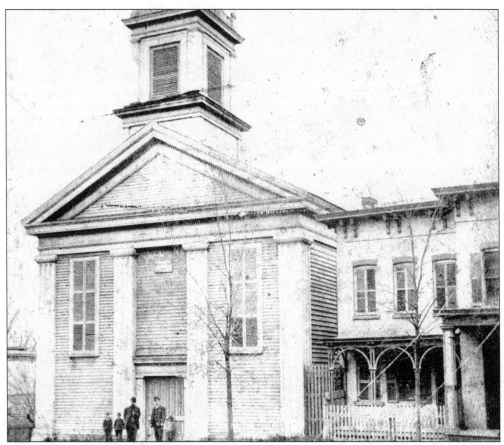

First meeting in the former Presbyterian church building on West Main and Market Streets, the Methodist congregation, after several moves, erected this edifice at 52–54 Market Street near Spring Street. Upon constructing a new church in 1883 on Pearl and Division Streets, the Methodists sold the 1845 building, which became first an opera house, then the YMCA, and later the site of the Wagenheim Block. (OFJ.)

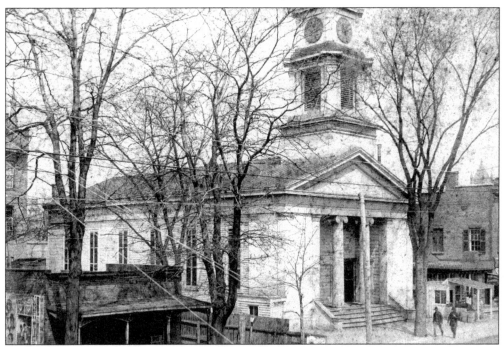

The congregation of the Baptist church formally organized in Amsterdam in 1825 with Reverend Corwin as the first pastor. A brick structure on Main Street preceded this 1842 edifice erected on Market Street. The congregation's third structure, built at 66–72 Division Street in 1892, was acquired by the Amsterdam Urban Renewal Agency in 1969 and demolished to make room for apartment housing. (OFJ.)

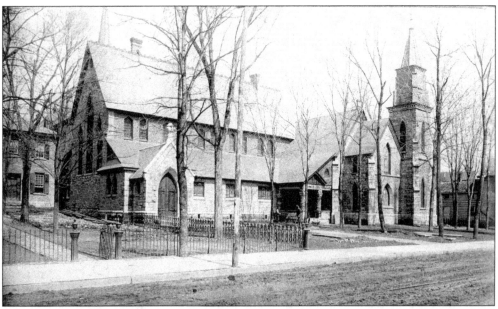

Constructed in 1851 on Division Street, this Gothic-style edifice was the second structure in which St. Ann's congregation worshipped. The Anglican parish previously worshipped in Port Jackson, tracing its lineage back to the 18th-century Queen Anne's Chapel in Fort Hunter. (OFJ.)

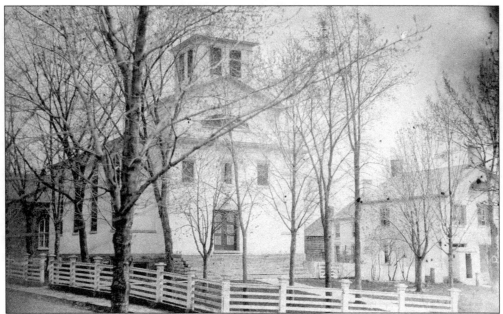

Amsterdam's Second Presbyterian Church (the First Presbyterian congregation being at Manny's Corners) constructed a framed building at Church and Grove Streets in 1832. The original structure and the church parsonage, to the right, are visible here in 1865. After it was demolished, a second structure, made of brick, was erected on the site in 1870. After a fire destroyed that ornate building and its Tiffany stained-glass windows in January 2000, a third house of worship was built on the site. (OFJ.)

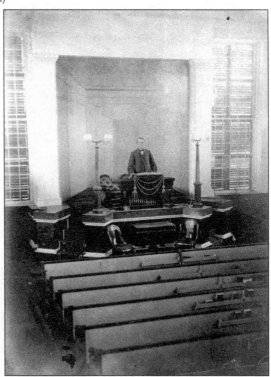

Rev. Dr. M. S. Goodale, pastor of the Second Presbyterian Church, stands at the pulpit of the 1832 church structure in 1868. Known for bringing large numbers into the congregation, it was during Goodale's pastorate (1836–1870) that the expansive brick church was dedicated. (OFJ.)

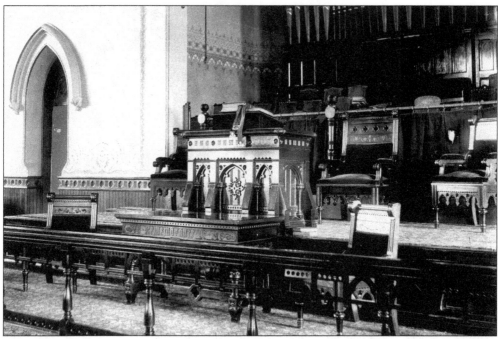

The Trinity Lutheran congregation, predominantly German, built its first church on Grove Street in 1869. However, it removed to a new place of worship on Spring Street (later Guy Park Avenue) in 1887 when the former building became too small and required repairs. The interior of Trinity Lutheran Church is seen here at 42–44 Guy Park Avenue. (H&A.)

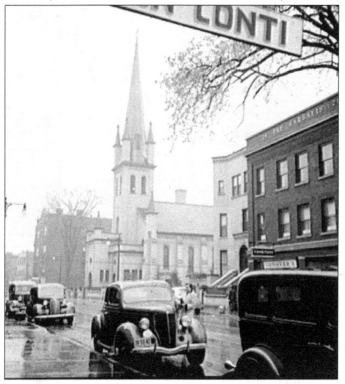

Irish Catholics who settled nearby in the Cork Hill section of the city largely attended St. Mary's Catholic Church, built on East Main Street in 1870. The Irish moved to this location from the south side of the Mohawk River where they participated in digging the Erie Canal. This photograph shows the church and part of its complex in 1940. (Library of Congress, Prints and Photographs Division, FSA-OWI Collection, [reproduction number, LC-USF34-081258-E DLC].)

The parsonage for the First Reformed Church was completed at 61 Arch Street in 1900, 50 years after the congregation organized. The Reverend Dr. Joshua R. Kyle preached from the church's pulpit for the more than 40 years. The church itself was located on the corner of Arch and Center Streets. (H&A.)

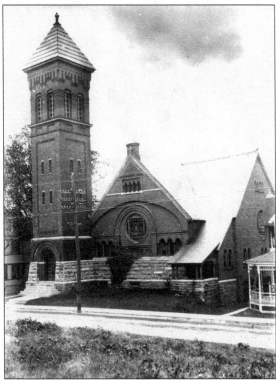

When members of the Second Presbyterian Church congregation felt that a church of that denomination should exist on the west side of the city, the Emmanuel Presbyterian congregation organized. It constructed this place of worship at 216 Guy Park Avenue in 1888. The two congregations again became one when they merged to become the United Presbyterian Church in 1995. (H&A.)

In 1869, this church building was constructed on Grove Street to house the German Lutheran congregation. A split in that congregation resulted in the formation of the Zion Lutherans, who used the building until they built a new brick structure on the northwest corner of Grove Street and Liberty Street in 1909. The structure was purchased by the Roman Catholic parish of St. Michael's predominantly Italian congregation and ultimately razed for arterialization of Route 5. (H&A.)

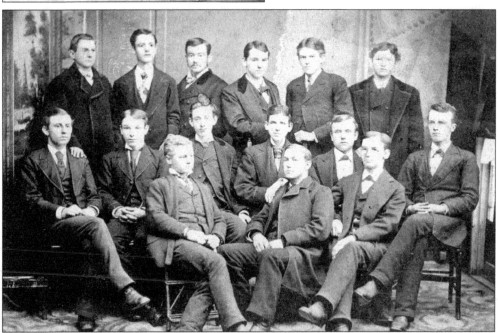

This 1876 photograph shows W. S. Reese's Sunday school class. From left to right are (first row) C. M. Morse, H. Eldrett, and Jim Eldrett; (second row) unidentified, Loren Eldrett, John DeGraff, Wm. Rowley, Geo. Mutimer, and unidentified; (third row) J. Stanton, unidentified, H. O. Wilkie, F. Roac, ? Bartlet, and B. Derby. (OFJ.)

Six

EDUCATION

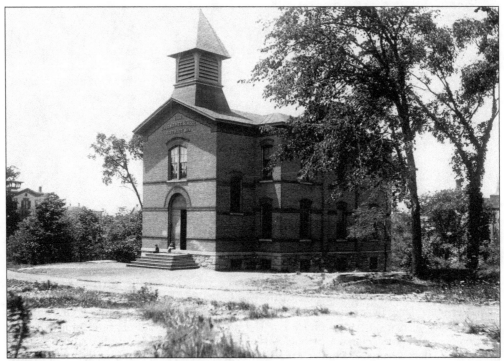

The majority of Amsterdam residents voted favorably on Union Free schools in an 1855 poll. Pictured here is the Union Free School District No. 9 in 1886. It later became the Eighth Ward School on Clizbe Avenue. (H&A.)

In 1865, the New York State legislature allowed a merger of the school on High Street and the female academy on Chuctanunda Street and granted a charter. The new Amsterdam Academy was constructed at the top of Wall Street on Academy Hill at a cost of $40,000. The first board of trustees included some of Amsterdam's most prominent citizens, such as Hon. Stephen Sanford, John Kellogg, and Adam W. Kline. From 1895, when the Amsterdam school district formed, the academy served as the high school until 1904 when a new structure was built. (H&A.)

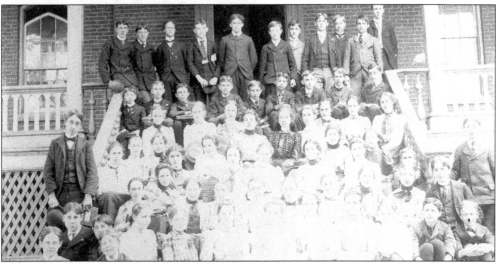

Students sit in front of Amsterdam Academy in 1901. From left to right are (first row) Ed Burgay and Gay Ostrom; (second row) Arthur Newell, Roy Loder, Laura Levey, unidentified, Ada Shuttleworth, Ethel Robb, Marietta Rees, Lucy Collins, Ethel Stratton, ? Nathan, and Jay Shults; (third row) Bert Steadwell, Laura Randall, Agnes Calhoun, Margaret McCleary, Jeanette Stratton, Edna DeHart, Ethel Hanson, Bertha Stone, Natalie Bennett, Winifred Stover, Gilbert Snyder, and unidentified; (fourth row) ? Martin, Ida Rogers, ? Cantine, unidentified, Lulu McDuffee, Jane Taylor, Irene Gower, Myrtle Denton, unidentified, Edna Porter, and two unidentified students; (fifth row) Grace Fox (Johnson), Caroline Powell, unidentified, Bertha Carnrite, Lena Rindnes, Florence Strong, Anabelle Clark, and two unidentified students; (sixth row) Milton Clark, George Ostrander, unidentified, Wallin McHarg, Bert Shuttleworth, Charles Gardner, ? Alter, unidentified, and Lloyd Hayes; (seventh row) Donald Grant, Floyd Cowley, Arthur Firth, James Shuttleworth, ? Childs, David Wilson (Dr.), Walter Becker, two unidentified students, Gifford Childs, and Alexander Kline. (FMCC-WEM.)

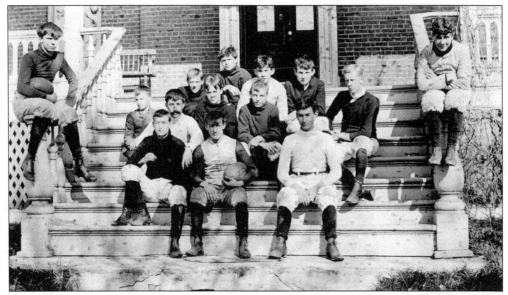

The Amsterdam Academy football team sits on the academy steps. Pictured from left to right are (first row) Henry Marcellus, Charles F. Stover, and Eugene Quiri; (second row) unidentified, Robert Hartley, Spencer Sladdin, unidentified, and Lewis Tinning; (third row) Mason Thayer, ? Sprague, unidentified, and Charles Inman. On left post is Romeyn Jansen (of Fonda). On the right post is William S. Phillips. (Jonathan Hubbs.)

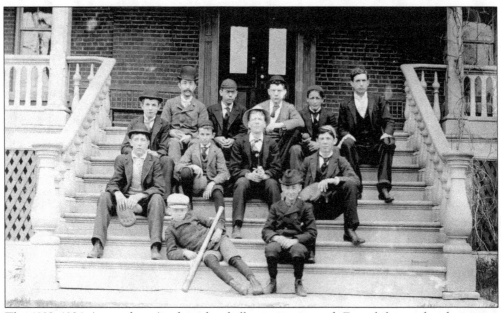

The 1893–1894 Amsterdam Academy baseball team is pictured. From left to right, they are as follows: (first row) Raymond Yund (mascot) and Sidney Newberger; (second row) Abram V. Morris and John Nolan; (third row) Charles Inman, Robert Hartley, and Edward B. Fitch; (fourth row) Prof. R. P. Green, Romeyn B. Jansen, Thomas Voight, Charles F. Stover, and Prof. R. E. Lee Reynolds. (Jonathan Hubbs.)

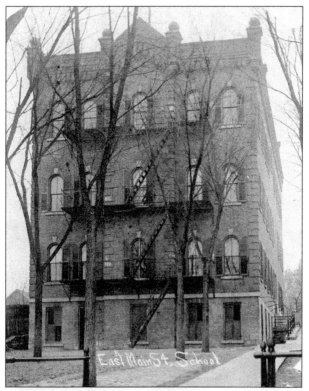

This site on East Main Street was used for educational purposes from 1808 until the early 1930s. The first framed building was destroyed by fire in 1858 and replaced by a small brick structure. In 1975, St. Mary's Institute moved its classes here when the institute on Forbes Street was taken down for construction of the Route 5 arterial. This enlarged 1876 District No. 8 school, seen here, was razed to make room for a parking lot. (H&A.)

Here is a class in the Arnold Avenue School in 1933. The Arnold Avenue School joined, in 1891, with the other schools as part of what would become the Amsterdam school district four years later. (FMCC-WEM.)

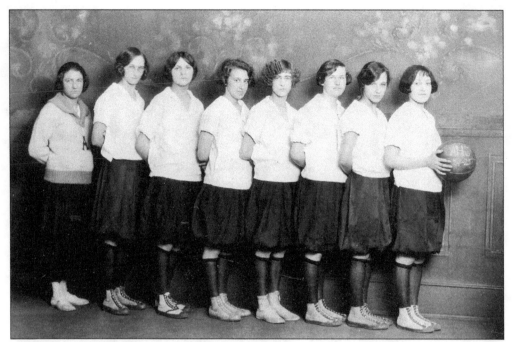

The Amsterdam High School girls' basketball team in 1924 includes, from left to right, L. Baetenfield (coach), E. Czurler, A. Belfance, I. Cross, R. Cengdon, A. Hall, M. Czurler, I. Amazon. (FMCC-WEM.)

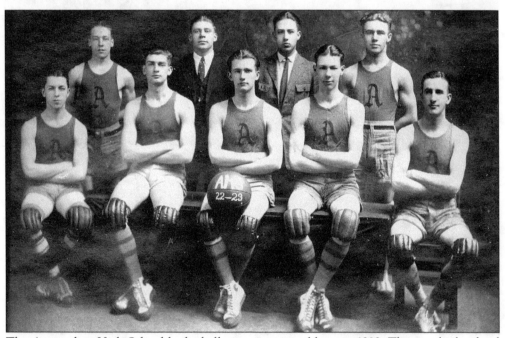

The Amsterdam High School basketball team is pictured here in 1923. The new high school was built on the site of the former Amsterdam Academy in 1917 to accommodate the city's growth in population. At that time, the average annual salary for an Amsterdam teacher was $516. (FMCC-WEM.)

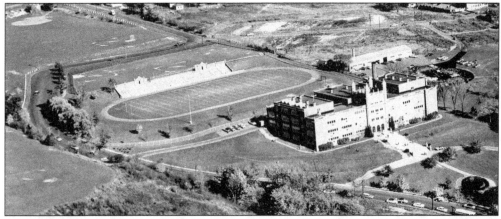

After World War II, New York State provided funds to erect temporary housing at the west end of Bunn Street for veterans and their families, who paid a modest rent and utilities. By 1958, however, approximately 30 families were evicted from the "flimsy structures" that were deemed unsafe by city officials. The houses were removed by the time this photograph of Wilbur H. Lynch school and athletic fields was taken in 1959. (H&A.)

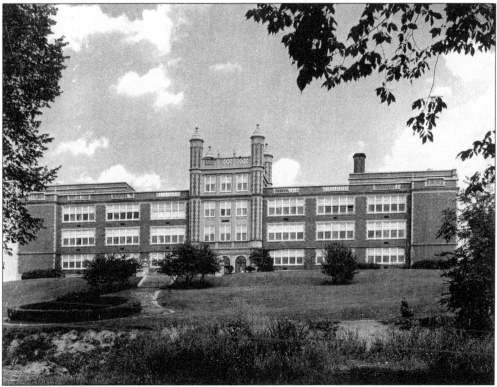

The 1904 high school was replaced in 1930 by a new structure, named after longtime superintendent Wilbur H. Lynch. At the time of this photograph, 20 years later, a vocational building was added to the campus. By 1977, with the construction of a new high school outside of city limits, the Lynch High School was transitioned into a middle school. (FMCC-WEM.)

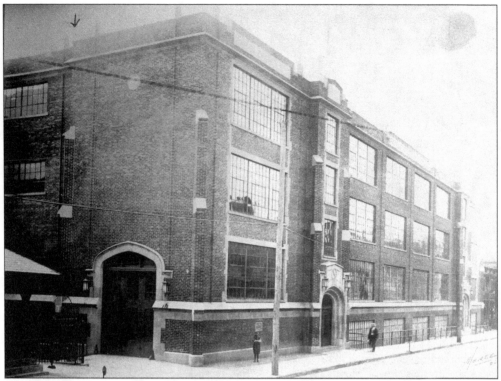

Theodore Roosevelt Junior High School, shown here in 1926, housed seventh, eighth, and ninth grades. It was erected on Guy Park Avenue in 1926. After Lynch became the middle school, Roosevelt was demolished as part of urban renewal. (OFJ.)

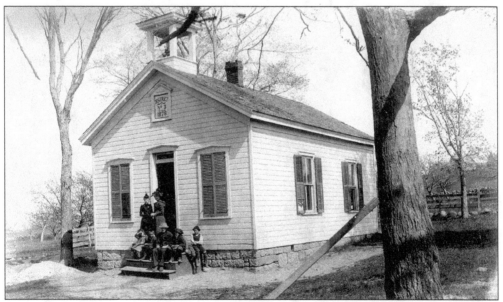

Beldens Corners Schoolhouse, seen here in 1878, was among the one-room schools that were eliminated in the formation of the Greater Amsterdam School District in 1967. (FMCC-WEM.)

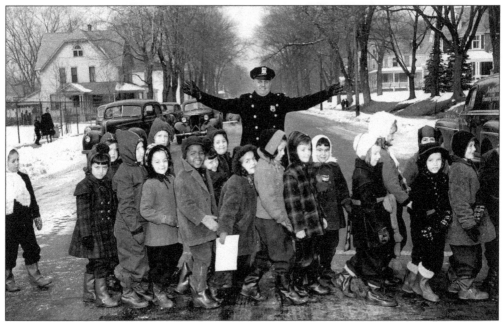

Guy Park Avenue School opened in 1902 as part of the city's expanding school district. The smaller neighborhood schools were phased out as other centralized schools were built to accommodate the suburban development. Officer Andrew Nelson, Guy Park Avenue School crossing guard, looks out for the safety of neighborhood schoolchildren in 1948. (FMCC-WEM.)

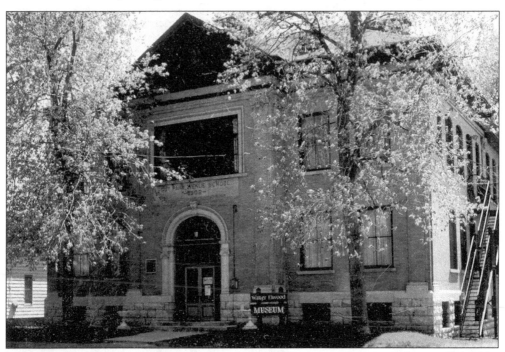

In 1968, the collection of artifacts relating to natural and social history and art, collected by former educator Walter Elwood, moved into the Guy Park Avenue School building. It became the school district's Walter Elwood Museum. (FMCC-WEM.)

Seven

SOCIAL LIFE

The annual circus parade passed the corner of Church and Main Streets in 1912. That year, there were two circuses that came to town, Sautelle's Circus and Downie and Wheeler's Circus. An early circus held on the east side of the Chuctanunda Creek behind the Globe Hotel included performers throwing handsprings around the ring and walking on stilts. (FMCC-WEM.)

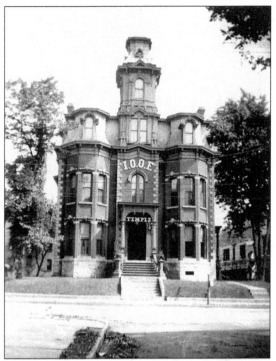

The McDonald homestead on Division Street was purchased and enlarged in 1898 for use as the IOOF hall when, together with auxiliary groups, the organization numbered close to 800. After the popularity of the fraternal organization waned, the Greater Amsterdam School District took over the hall, using the building to house administrative offices before it was razed. (H&A.)

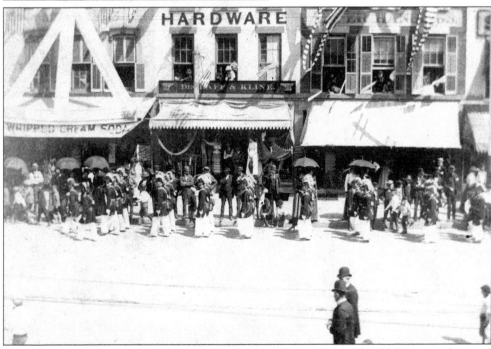

The Canton Amsterdam IOOF parade was held in August 1895. The IOOF was a fraternal organization that first formed locally in 1845 and then again in 1866. In 1916, Amsterdam Supreme Court judge Henry V. Borst was elected to the second-highest position in the order, only to achieve the highest position of grand sire at the national IOOF convention in St. Louis two years later. (H&A.)

The Elks Club, another of Amsterdam's fraternal organizations, held its meetings in the Sugden building on Market Street. A new building, constructed by John F. Morris, was erected and dedicated in 1910 here at 105 Division Street west of Market Street. It was an impressive structure that was the scene of many social functions. (H&A.)

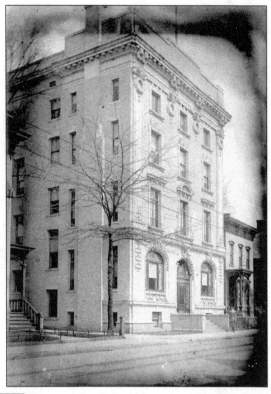

The Pythian temple, at 18–20 Guy Park Avenue, was built in 1892 and dedicated on May 15, 1894, thirty years after the Knights of Pythias organized locally. This structure, located at the foot of William Street, was the first large structure built by a fraternal organization. The Pythians had a widely renowned band that drilled and won numerous competitions. (H&A.)

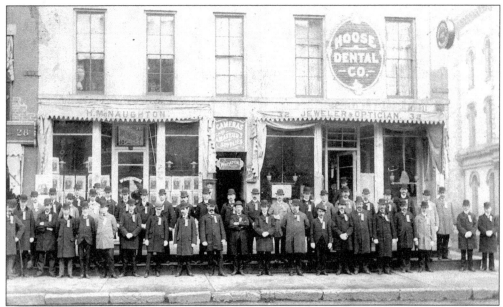

In 1897, the Knights of Columbus, a Catholic organization, was founded in Amsterdam with 42 charter members. Meetings were held at a Church Street residence, as well as on the third floor of the Rialto Theater before moving to the west side of Market Street in 1965. Here they wait for a parade at Main and Chuctanunda Streets in 1890. Van B. Wheaton's photography studio sits among the businesses in this block. (FMCC-WEM.)

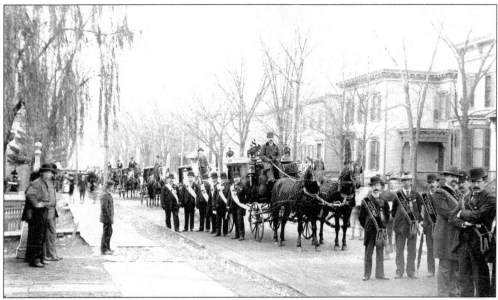

The Artisans Lodge, Free and Accepted Masons 84, first formed in 1824 only to reorganize in 1854. In 1921, the Masons took over the Sugden building on Market Street. A large turnout of members from the local Free and Accepted Masons lodge attend the funeral of fellow member Charles J. Landry held on November 8, 1895. Landry's death made headlines when it was discovered that his mistress Florence Haun murdered him. Haun was convicted and sentenced to prison at Auburn, where she died in March 1897. (H&A.)

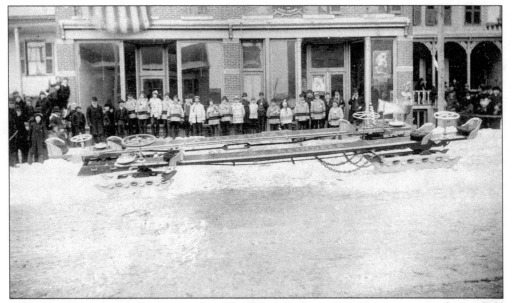

Atlanta and Reindeer sled teams stand on West Main Street in 1890. Coasting carnivals were held in the city during the winters. Rivalries were fierce among groups, including those that came from other areas such as Albany. Festivities were headquartered at the Hotel Warner. The 13th Brigade Band provided musical entertainment. Sleds zoomed down the city's sloped streets. Despite the excitement, many injuries and fatalities occurred, leading to bans of these events. (FMCC-WEM.)

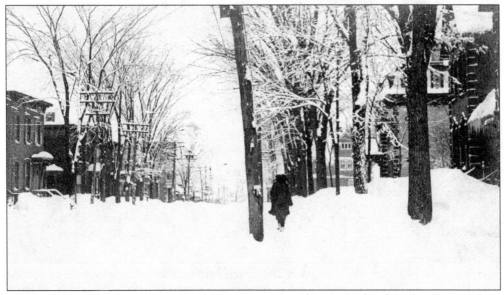

On March 28, 1919, the worst storm of the winter occurred in the Mohawk Valley. One resident, seen here on Storrie Street, tries to venture through the piles of snow. (H&A.)

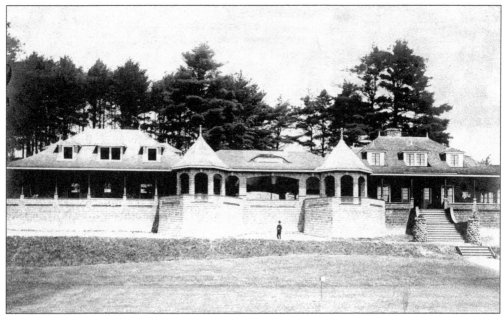

As Amsterdam prosperity brought wealth to many of its residents, this well-to-do population sought a place to relax and have fun. In 1900, the Lepper farm between Tribes Hill and Fort Johnson was purchased, and the Antlers Country Club was organized. Golfing, tennis, and cricket were a few of the sporting events held on the grounds, while the clubhouse held plays, dances, and dinners. (H&A.)

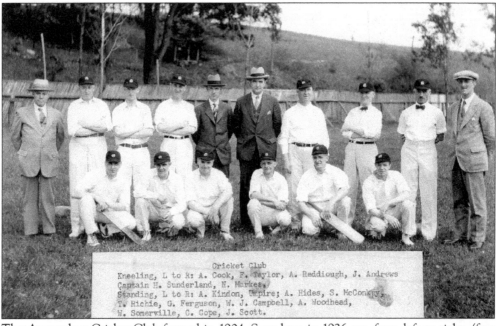

The Amsterdam Cricket Club formed in 1904. Seen here in 1926 are, from left to right, (first row) A. Cook, F. Taylor, A. Reddiough, J. Andrews, captain H. Sutherland, and N. Markes; (standing) umpire A. Kindon; A. Hides, S. McConkey, T. Richie, G. Ferguson, W. J. Campbell, A. Woodhead, W. Somerville, C. Cope, and J. Scott. (FMCC-WEM.)

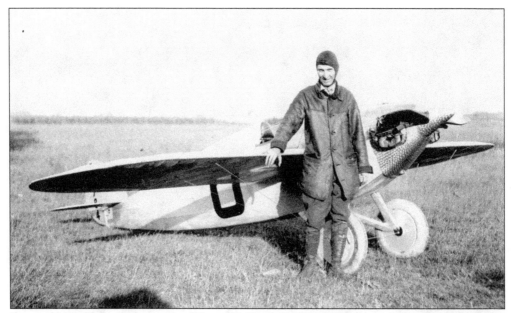

Pictured here is Amsterdam native Edward B. Heath (1888–1931) at a test flight of his Baby Bullet racing plane on August 19, 1928. He successfully flew his first airplane at the Antlers Country Club in 1910. Heath went on to sell planes in kit form, catering to aeronautical enthusiasts. His Chicago-based company was a major supplier of hardware to firms constructing planes used during World War I. Heath died when testing his Low Wing model in 1931. (H&A.)

A group of employees from Bowler's Brewery enjoys an outing at Phillips Park in 1928. Phillips Park, located east of the city on the south side along Route 5 south, was bequeathed to the city by John P. Phillips in 1911. Although not selected, the park had been in the running to become the location for the Amsterdam Municipal Golf Course. (FMCC-WEM.)

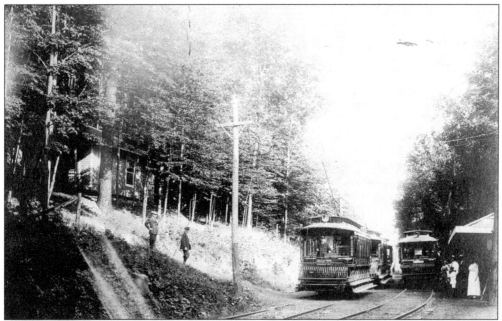

In 1914, a realty group headed by Edward and Thomas McCaffrey developed land east of Locust Avenue that became known as Crescent Park. There were many things for families to do, including games and rides. A rail station at Crescent Park allowed for easy access from the city via the FJ&G. (FMCC-WEM.)

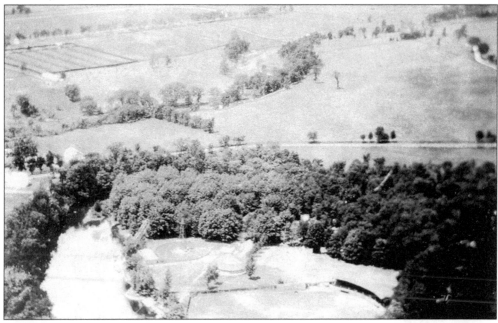

Fred J. Collins took over management of Crescent Park in 1923, changing its name to Jollyland. With its miniature train among the many rides, Jollyland entertained thousands of area children. Over time, corporate management resulted in further name changes, the park later becoming Mohawk Mills Park and finally Shuttleworth Park. This was home to the Little Yanks, a Canadian-American League baseball club. (FMCC-WEM.)

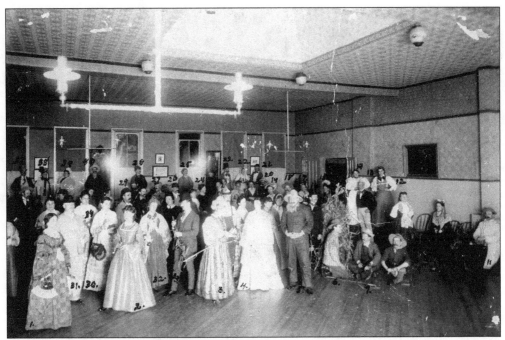

Members of the Amsterdam Married People's Dancing Class held a masquerade ball in the old GAR hall in the late 19th century. Walter L. Curtis was the dance instructor. The GAR hall was located at 45 East Main Street. Prominent Amsterdam families attended this event. (H&A.)

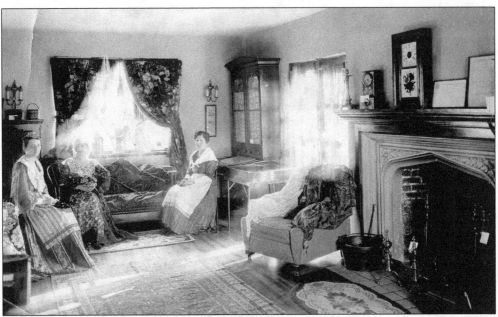

The Century Club, organized in 1895, had an exclusive membership that focused on cultural programming. It met in the Sanford Homestead building on Market Street prior to erection of its clubhouse on Guy Park Avenue in 1933. A Century Club exhibit was on display, in 1932, at the residence of Mrs. William Charles Jr. From left to right are Mrs. P. Rider, Mrs. William Crane, and Mrs. Robert White. (FMCC-WEM.)

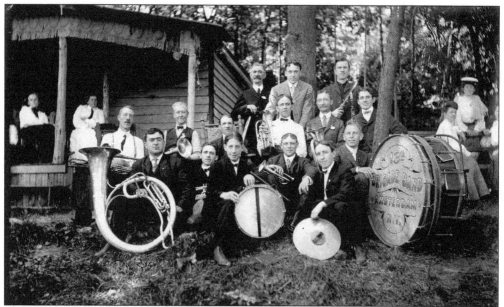

The 13th Brigade Band entertained at many of Amsterdam's social functions. In August 1902, along with the Maney and McNaughton Orchestra, the band played at the opening of the new electric line to Hagaman at the Chuctanunda Park north of Rockton. The man in the center of the back row is John A. Maney, musician and amateur photographer, responsible for capturing the imagery of Amsterdam in its heyday. (H&A.)

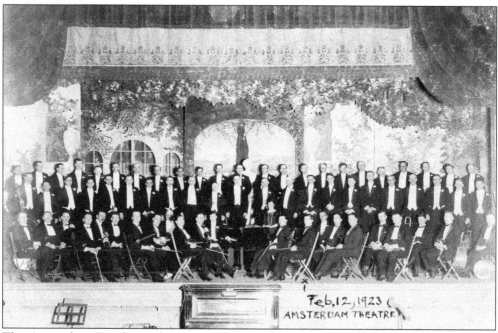

The Amsterdam Symphony played at the Amsterdam Theatre on February 12, 1923. Three years earlier, the Russian Symphony Orchestra gave a concert there. The theater, located at 97–99 East Main Street, also held theatrical productions and vocal concerts, along with mass meetings for church and political organizations. (FMCC-WEM.)

In the late 1700s, Garret Roseboom constructed a stage house on the Mohawk Turnpike that would later become the home of Dr. Samuel Voorhees and Betsy Voorhees (née Reynolds). An "Egyptian princess" iron doorknocker adorned the front of the simplistically elegant mansion. An interior view of the mahogany woodwork and the carved moldings can be seen here. The two-story structure was dwarfed on each side by the 1910 construction of the Hotel Conrad. Both were demolished in urban renewal. (OFJ.)

The Gardinier Kline home, formerly a schoolhouse on the Thomas Bunn property, was moved by John Van Derveer to the corner of Arnold Avenue and Market Street, where his daughter Mary lived. Mary Van Derveer (1865–1945) was a well-known area portrait artist and still life painter who had been trained in Europe. (H&A.)

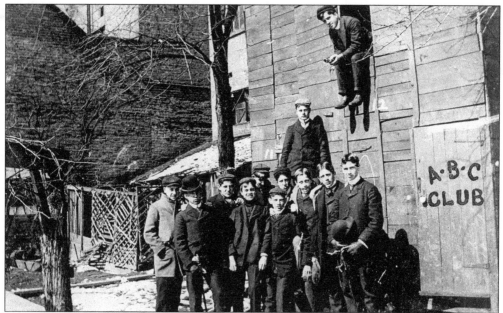

The ABC Club organized around 1900 and included Walter J. Becker, John Firth, DeLacey Chapman, Burtiss E. Deal, Edward G. Davey, Harold B. Kline, Benjamin Lowenstein, Raymond Stover, George K. Morris, Kenneth McEwen, D. Cady Crane, and Ward Chalmers. The clubhouse was erected behind the Bennett home at 26 Church Street. The group took its name from ABC remedies manufactured by N. C. Becker, Market Street druggist and father of a club member. (OFJ.)

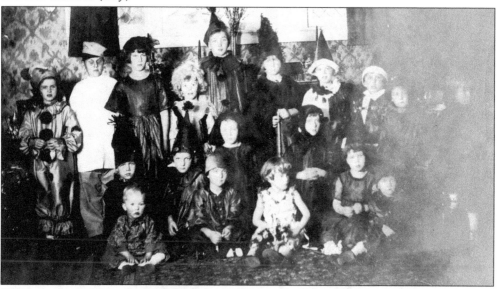

Children of some of Amsterdam's leading citizens attend a Valentine's party in the 1920s. Shown here from left to right are (first row) Lew Morris, Mary Gardinier, Edna Collette, Frances Hill, and Patricia Peebles; (second row) Sandy Peebles, James V. Hogg, John D. Kellogg, and Mary Anne Voorhees; (third row) Mary Wilkinson, Vedder Gilbert, Nancy Morris, Janet ?, Frank Morris, Grace Dunlap (née Bunty), Christine Waldron, Henry Wheeler, William Dunlap, and Tommy Kennedy. (Jonathan Hubbs.)

Located at the intersection of West Main and Pearl Streets, Kellogg Park was renamed in January 1921 after a vote of the common council. The new name, Bergen Park, honored Lt. James Bergen, an Amsterdam resident serving with the 27th Division who was killed in France on October 17, 1918. On December 10, 1925, hundreds of children welcome Santa Claus on his arrival at Bergen Park. (FMCC-WEM.)

Heavyweight boxing champion Jack Dempsey had a match with Gene Tunney in a title fight on September 23, 1926, in Philadelphia, which resulted in Tunney's win. Amsterdam residents watched an exhibition match, held on August 21, 1926, where L. Adebahr and T. F. McNeil boxed in preparation for the upcoming Dempsey-Tunney fight. (FMCC-WEM.)

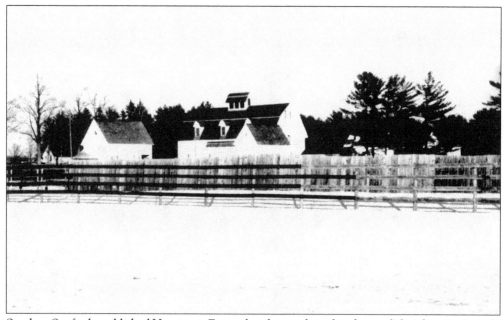

Stephen Sanford established Hurricana Farm when he purchased and consolidated approximately 1,000 acres of farmland north of the city limits in the late 1870s. With a half-mile track, indoor track, and lavish outbuildings, the farm was home to the winner of the 1916 Kentucky Derby. In June 1903, the public was treated to a free attendance of Thoroughbred races at the farm. The Sanford family kept horses here until 1977. (H&A.)

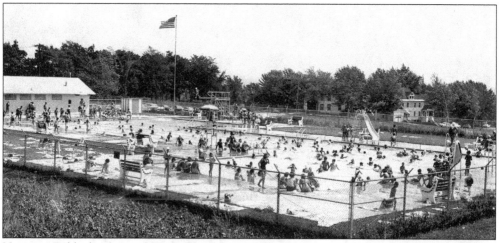

Veterans Field, the former Van Derveer farm on Locust Avenue, was purchased as a 50-acre tract in 1920 for the recreation of employees at Sanford Carpet Mills. Prior to this purchase, the site had held the circus tents of the Barnum and Bailey Circus in 1909. Bigelow-Sanford turned the park over to the city in 1955. Residents enjoy the public pool at the Amsterdam Recreation Department here in 1971. (FMCC-WEM.)

Eight

HAMLETS

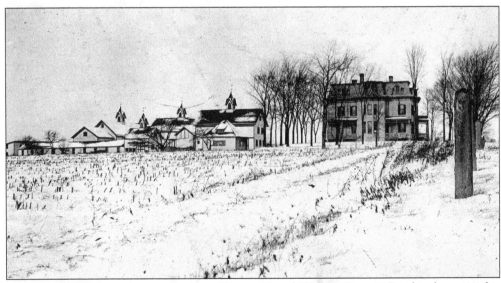

The Elmwood farm at the intersection of Route 30 and Wallins Corners Road is shown in this photograph taken around 1919. The farm was purchased by Stephen J. Collins about 1864 when he was 21 years old from money he and his brother, Teunis, made from running a threshing machine. He was elected in 1888 as town supervisor. The site is now occupied by the Alpin Haus Plaza. (H&A.)

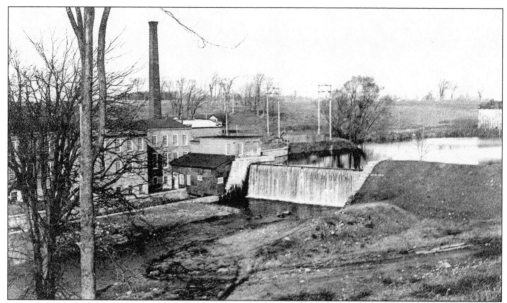

Harrowers was a hamlet on the North Chuctanunda Creek above Rockton. This view shows the Rural Hosiery Mill built by William Pawling in 1871. It was purchased by Lewis E. Harrower about 1880 and produced knit shirts and underwear. The dam near the mill provided waterpower from Galway Lake. Harrowers contained several dozen houses and a general store run by Edward and Maurice Fitzgerald by the 1890s. (H&A.)

This is Lewis E. Harrower's home in Amsterdam as it looked before the addition of pillars. Harrower bought the Rural Hosiery Mill with F. W. Wainman in July 1880. Harrower became the sole owner in 1881 and employed most of the hamlet's 350 residents by the 1890s. Harrower's home is on the corner of Northampton Road and Guy Park Avenue. (H&A.)

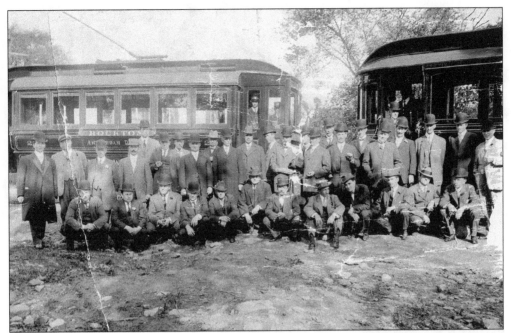

Conductors on the Amsterdam-Rockton trolley line pose for this photograph in the 1890s. In the 1850s, Rockton, located one and a half miles from the city, was comprised of a couple of sawmills. By 1900, it contained at least six substantial knitting and carpet mills and a sizeable population. One of the largest mills was built by McCleary, Wallin, and Crouse and later became the upper mill of Mohawk Carpets. (FMCC-WEM.)

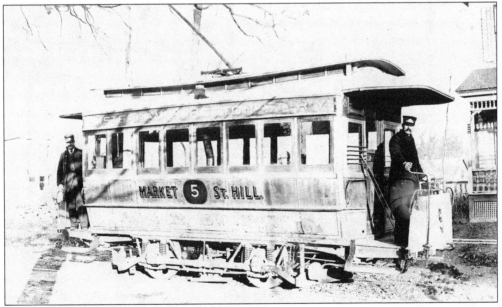

Here is an early car on the Amsterdam-Rockton Street Railway that opened in December 1890. The line ran from Division Street up Market Street to Brookside Avenue over Lyon Street to Rockton Street. The line was continued to Hagaman in 1902. This line served many of the workers in the Rockton mills who lived in Amsterdam. (OFJ.)

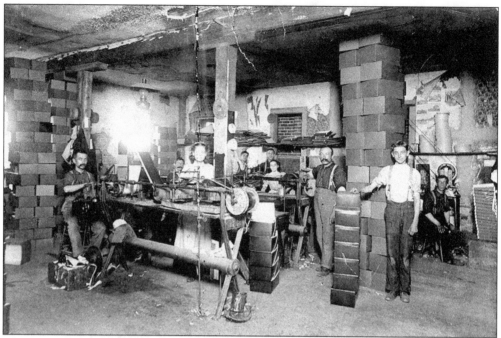

This late-19th-century photograph shows inside the paper box factory in Rockton. It was founded by Frank H. Levy in the 1890s and furnished cardboard boxes to the many knitting mills there. Rockton also had a Methodist church, a school, a drugstore, and four grocery stores by 1900. (FMCC-WEM.)

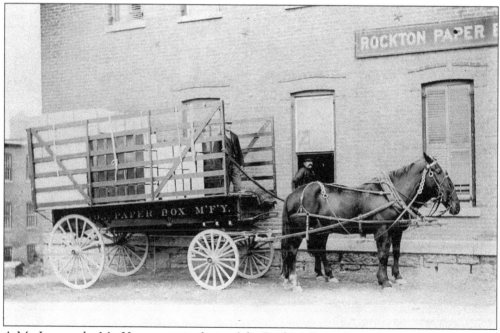

A Mr. Levy and a Mr. Henry pose in front of the Rockton Paper Box Factory about 1890. The box factory made plain and fancy boxes for knitting mills in Rockton like the Park Knitting Mills, which produced scarlet underwear. (FMCC-WEM.)

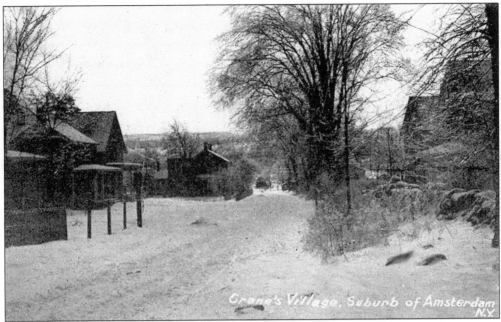

Cranesville, located about three miles east of the city, is one of the oldest settlements in the county. This 1900 view shows Cranes Hollow Road looking south to Route 5. Cranesville was named for David Crane, who settled here in 1804 and operated a hotel called the Riverside. Cranesville farmers cared for Erie Canal horses during the winters, charging $1 per week. (FMCC-WEM.)

The Edward DeGraff home was located on Route 5 at Tellers Station in Cranesville. This land was a portion of a grant given to Isaac DeGraff by King George III. Edward's father, J. Teller DeGraff, was town supervisor from 1880 to 1886. Edward worked for the Farmers National Bank and managed real estate. (H&A.)

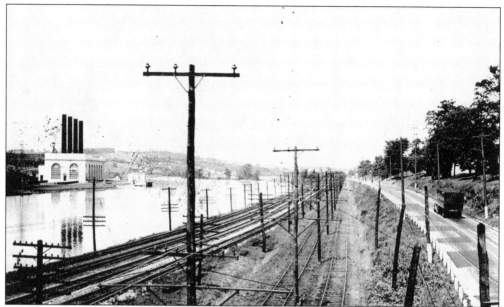

This 1935 view shows Route 5 looking west from Cranesville, with four main tracks of the NYCRR, the two tracks of the electric line to Schenectady of the FJ&G and the two-lane Route 5. The large building at left was the Adirondack Power and Light plant that furnished power to the Mohawk River Barge Canal when it opened in 1918. At one time, travelers along the NYCRR were captivated by the building's beautiful ornate appearance when lit up at night. (Scott G. Haefner.)

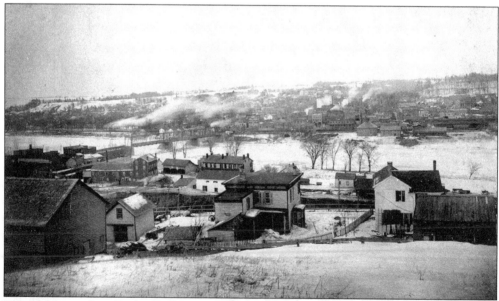

This is the view from Yankee Hill in Port Jackson looking north toward Amsterdam about 1880. Port Jackson was a small outpost of three or four houses until 1822 when the section of the Erie Canal from Schenectady to Little Falls opened and a bridge was completed across the Mohawk River. Until 1835, the village was called Stillwellville after John Stillwell, who operated two canal stores here. (FMCC-WEM.)

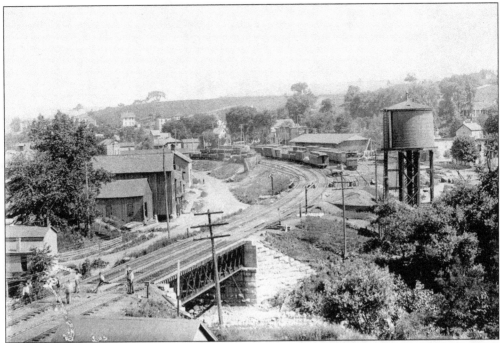

The West Shore rail yards are shown in this view in Port Jackson taken from Yankee Hill about 1890. The West Shore Railroad opened a double line from Coeymans to Utica in 1880 in competition with the NYCRR on the north side of the Mohawk River. Port Jackson became the fifth ward of the city of Amsterdam on April 15, 1888. (FMCC-WEM.)

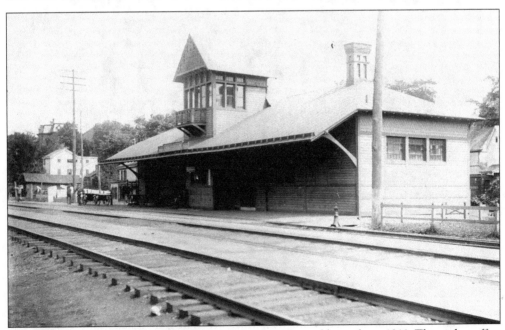

The West Shore passenger station in Port Jackson is pictured here about 1910. This ticket office and freight station was located where the tracks crossed Bridge Street. Port Jackson was an important rail-to-canal transfer point in Montgomery County. (H&A.)

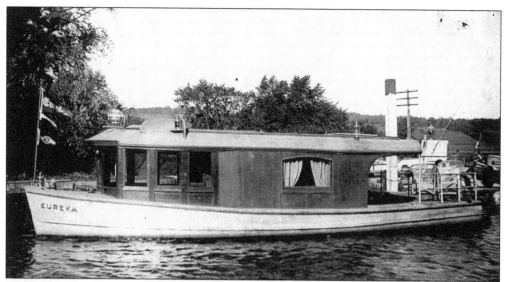

The *Eureka* at Port Jackson is shown about 1910. This excursion launch was an early electric boat run by batteries and made by General Electric. It operated on the Erie Canal as a tour boat. The railroads gradually took away the passenger traffic and the freight shipments from the canal, and in the last years, excursion boats mainly used it until it closed in 1915. (FMCC-WEM.)

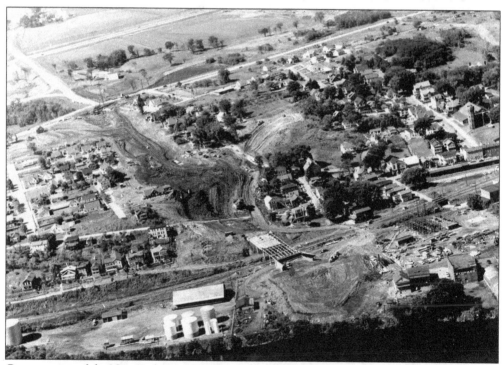

Construction of the New York State Thruway exit 27 interchange and bridge was photographed in 1959. The highway modernization program, which began in 1956, lasted nearly 25 years. The north–south Route 30 interchange replaced the 1916 bridge over the Mohawk River with a four-lane highway and numerous bypasses that necessitated the removal of large parts of the old Port Jackson business district. (H&A.)

Here is part of the knitting mill of A. V. Morris and Sons at Fort Johnson. Ethan Akin, who owned the Sir William Johnson home here in the 19th century, sold about 30 acres behind Old Fort Johnson to Abram V. Morris in 1887. The mill employed about 150 workers and made knit sweaters. Because of the mill and the surrounding businesses, the village of Fort Johnson was incorporated in 1909. The Morris mill burned to the ground in 1915. (OFJ.)

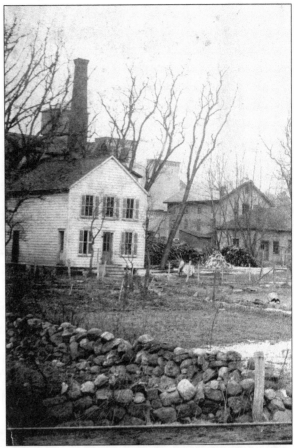

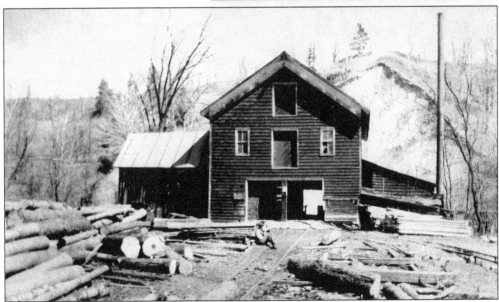

This view shows the Cider Mill and Sawmill at Fort Johnson about 1900. It was located near where East Main Street crosses Lepper Road and operated until before World War II. (H&A.)

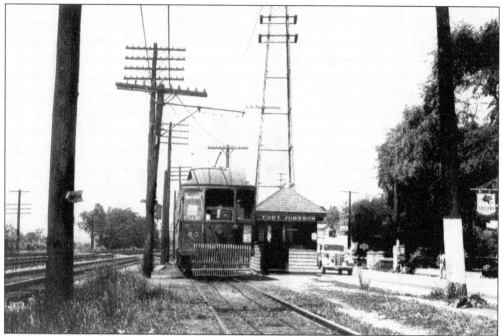

A Brill-manufactured FJ&G enclosed car (No. 60, built in 1910) stops at the Fort Johnson stop on the corner of Routes 5 and 67 about 1935. This line was part of the Amsterdam Street Railroad and opened in 1891. The stop was known as Akin until the village was incorporated in 1909. (FMCC-FJ&G.)

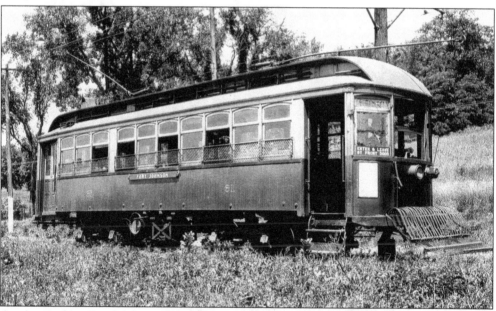

An Amsterdam–Fort Johnson car, on the FJ&G line in the early 1930s, stops on Route 5 near the Antlers Golf Course. This is car No. 61, built by the Brill Company about 1910. The line to Fort Johnson was taken over from the Amsterdam Street Railroad Company by FJ&G in 1903 and closed in 1938. (FMCC-FJ&G.)

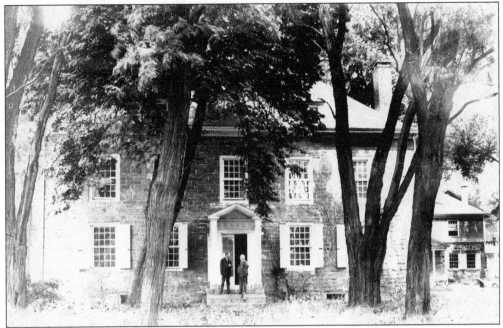

Alpha Childs (left) and Freeman T. Milmine converse in front of Old Fort Johnson in 1906. In 1905, Fort Johnson was purchased by philanthropist Maj. Gen. John Watts DePeyster and donated to the Montgomery County Historical Society. Old Fort Johnson was opened to the public as a historic site on September 19, 1906. Childs was the first caretaker of the site, and Milmine was a founder of the historical society in 1904. (H&A.)

In 1940, members of the Village Playhouse group of Fort Johnson include, from left to right, ? Lasher, J. Gage, Doris Brumley, ? Overocker, ? Champlin, ? Fields, ? Tane, ? Totten, and ? Coles. Playhouse member Doris Brumley was named Miss New York State in 1948. The playhouse productions were given at the Methodist church on Fort Johnson Avenue. (FMCC-WEM.)

The All-Girl Fife and Drum Corps of Fort Johnson is pictured here about 1950. A marching group, the All-Girl Fife and Drum Corps would practice and play at the baseball field in the evening for an hour before games in the summer. Most of the corps members lived in the city of Amsterdam. (FMCC-WEM.)

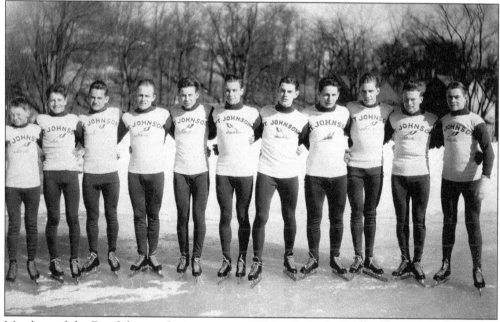

Members of the Fort Johnson skating team in 1945 include C. Snyder, D. Reisigle, B. Kuczer, H. Flesh, D. Talmadge, G. Hare, R. Snyder, and Ted Ellenwood. Each winter, the baseball field off Route 67 would be flooded for ice-skating. Ted Ellenwood was the North American speed skating champion in the late 1940s. (FMCC-WEM.)

112

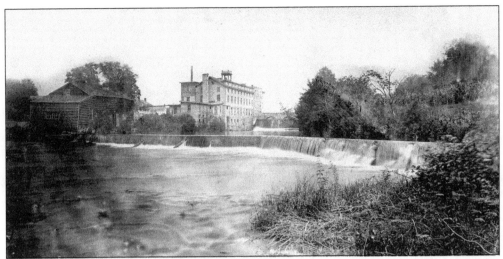

This is the Anchor Knitting Mill in Hagaman. Henry Pawling began manufacturing cloth here about 1845. In 1879–1880, his son William built this mill and with his brother, Haskell, and their father operated under the name H. H. Pawling and Company. By the 1890s, it produced 120 dozen pairs of scarlet knit underwear a day. (HHS.)

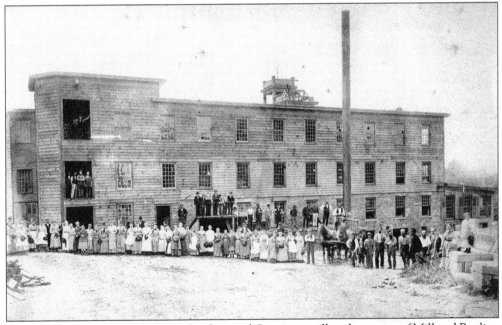

Workers stand in front of the H. H. Pawling and Company mill at the corner of Mill and Pawling Streets in Hagaman. Henry Pawling's first mill was destroyed by fire in the 1840s, and in 1871, he went into partnership with a Mr. Jackson and started to manufacture knit goods. By 1878, he had bought out Jackson and was making 60 dozen shirts a day, employing about 80 people. Lewis E. Harrower took down the mill in 1903. (HHS.)

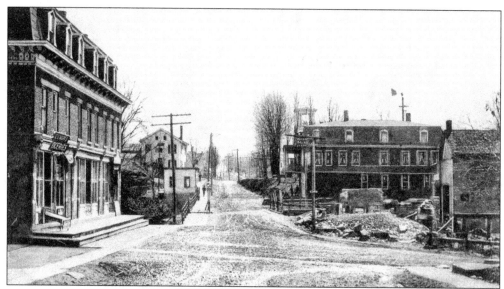

This view is of Pawling Street in Hagaman looking south. Joseph Hagaman settled here shortly after the Revolutionary War and started a sawmill and a gristmill here. It is said that while erecting the sawmill, the settlers decided to give the name Amsterdam to this section of the old Caughnawaga District, and the name was retained when the town was organized in 1793. (HHS.)

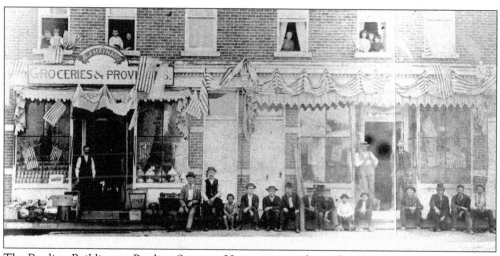

The Pawling Building on Pawling Street in Hagaman is in the midst of a celebration, as apparent from the banners and decorations draped across the building. Built by H. Haskell Pawling, who owned the Star Hosiery Mill, it was the main business block in the village. (HHS.)

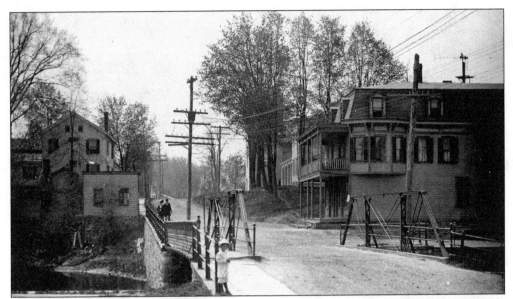

This view shows Pawling Street in Hagaman looking toward the bridge over the Chuctanunda Creek. The small building at left was the barbershop. Notice the little girl standing near the bridge in this 1913 photograph. (HHS.)

This is Joseph Tierney's Shaving and Hair Cutting Parlors in Hagaman about 1910. The barbershop sat next to the Chuctanunda Bridge on Pawling Street across from the hotel. (HHS.)

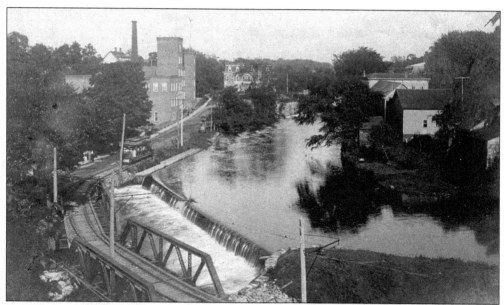

Hagaman is pictured looking north toward the Star Hosiery Mill. The dam was made of cut stone laid in cement and was the only one of its kind on the Chuctanunda Creek. The electric trolley line was extended from Amsterdam to Hagaman in 1902. (HHS.)

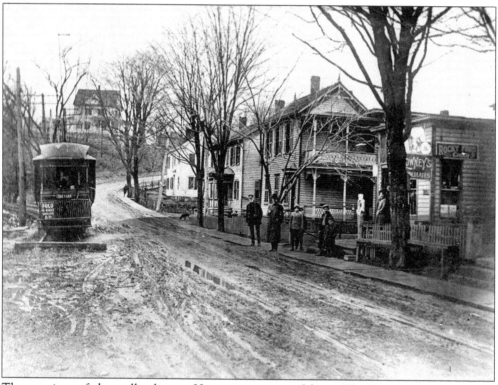

The terminus of the trolley line to Hagaman is pictured here. This line was built after the Amsterdam Street Railroad was taken over by FJ&G in 1901. Lowney's Drug Store served as the waiting room. (HHS.)

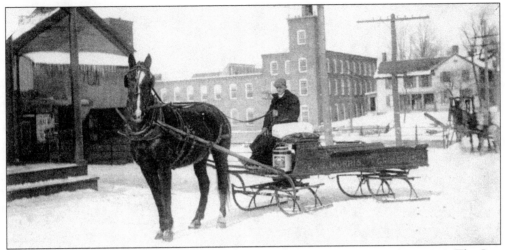

Here is the delivery sleigh of the E. S. Morris Grocery Store in Hagaman about 1900. The Star Hosiery Mill is in the background and the oldest house in Hagaman at right. (HHS.)

Dr. John M. Phillips, veterinary surgeon and overseer of the poor, stands in front of his home on Hagaman's Chuctanunda Street. (HHS.)

The delivery wagon of Banta and Blunck's Hagaman Dairy is pictured with Alvin Banta in the wagon. The Hagaman Dairy sold milk for 5¢ a quart, and it sold 100 quarts a day in 1895. (HHS.)

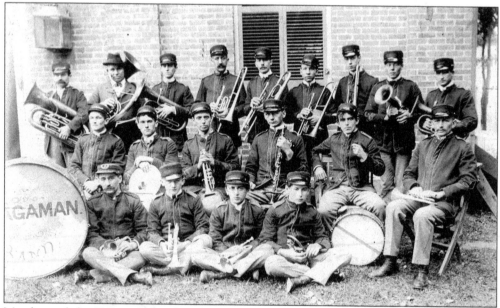

Members of the Hagaman Band are pictured here. From left to right are (first row) Frank Bowman, Herbert Breen, Max Fowler, and Malee Fowler; (second row) Edward "Doc" Davis, John Lang, George Wilkins, Charles Cook, Charles Hillman, and Frank Heiden; (third row) Joseph Clark, unidentified, Edward Wood, Raymond Irving, Arthur Snyder, George Peterson, Frank Menge, Merrill Shook, and George Lucht. (HHS.)

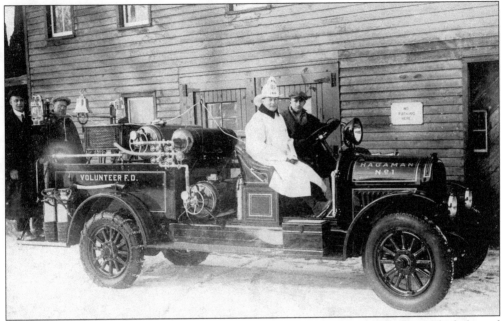

On July 7, 1925, village residents meeting at the post office in Hagaman's Briar Block formed the Hagaman Fire Department. The first firehouse on William Street, purchased from Lewis E. Harrower in 1938 for $400, was used until the present site was purchased in 1950. The Brockway truck, the department's first fire truck purchased in 1925, was replaced in 1946 with a 1942 army surplus fire truck. In 1954, fund-raising efforts allowed for the purchase of a new pumper. Eventually during the 1960s, the second firehouse building required remodeling and enlargement. (H&A.)

This is the Women's Christian Temperance Unit of Hagaman. From left to right are (first row) William Parker, Eleanor Mosher, Gladys Platt, Rev. Elmer West, Raymond Mosher, Emma Armer, Edna Personeus, and Winifred Banta; (second row) Carrie Brown, Grace Hess, a Mrs. West, and Frances DeGraff; (third row) Hettie Knope and Rose Platt; (fourth row) Sophie Hagaman, Jennie Ertl, Anna Knights, a Mrs. Harnish, Lottie Parker, Reverend and Mrs. Schnetzler, Mrs. Isaac Buchanan, Jennie Banta, and a Mrs. Sanders. (HHS.)

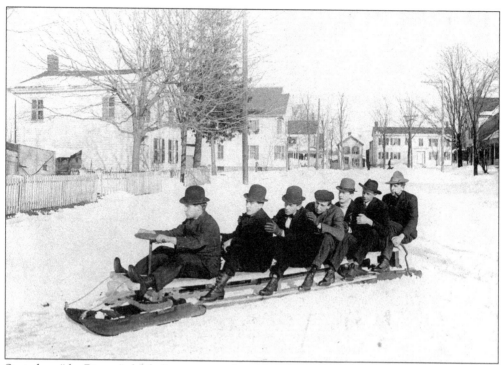

Seated on "the Ripper" sleigh (in no particular order) about 1900 is a Hagaman sledding group, including Dave Uhlinger (driver), Jake Tracey, Raymond Sawyer, Seymore Sanders, Elmer Sanders, George Blunk, and Morris Sanders. (HHS.)

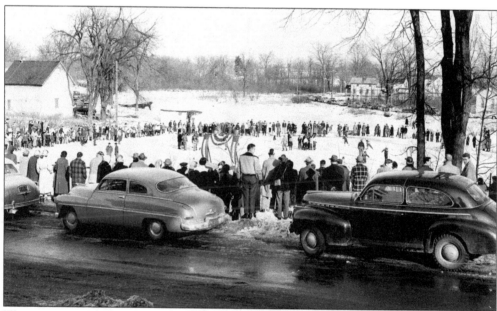

Winter activities were common occurrences and enjoyed by everyone, as evidenced by this January 24, 1954, scene of ice-skating in Hagaman. (HHS.)

The Hagaman baseball team was photographed about 1890. (HHS.)

The 1913 Hagaman baseball team is pictured here. (HHS.)

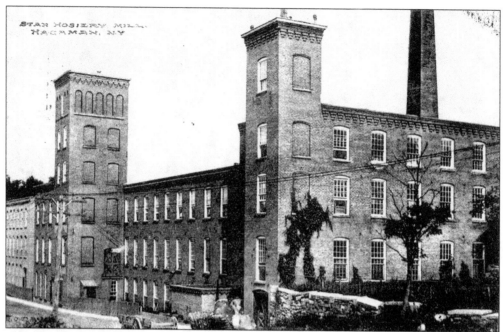

Henry Pawling founded the Star Hosiery Mill in Hagaman. The mill was taken over by his son H. Haskell Pawling in 1884. After a series of ownership transfers, the building was demolished in 1991 when it had fallen into disrepair from discontinued use. (HHS.)

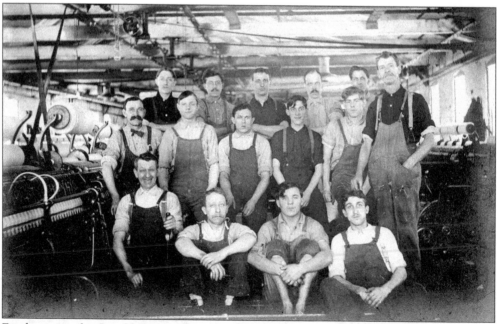

Employees at the Star Hosiery Mill in the spinning room are, from left to right, (first row) unidentified, Lars Johnson, David Uhlinger, and unidentified; (second row) three unidentified employees, Glen Fisher, Fred Packman, and unidentified; (third row) Morris Reed, unidentified, George Tracy, George Stark, William Traver, and Morris Sanders. By the 1890s, the Star mills had 1,000 spindles for making thread and 81 knitting spindles. (HHS.)

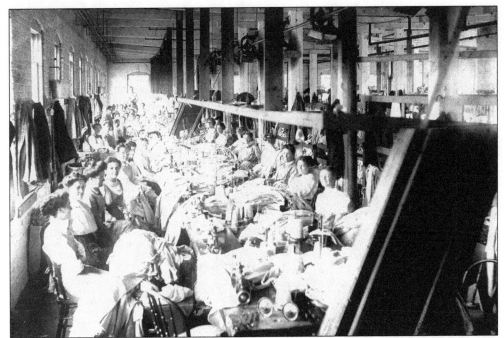

Workers are shown in the finishing room of the Star mill. Besides hosiery, the mill manufactured scarlet and fancy underwear. The second woman on the left is Nellie Collins. Next, to the right, is Louise Saulwater, and fifth from left is Mary Saulwater (HHS.)

Mayor Fred Packman of Hagaman is pictured at the honor roll monument in the mid-1940s. Henry Pawling's mill was on this site until it was taken down in 1903. In the background is the Star mill. (HHS.)

In 1835, the Calvary Reformed church at Hagaman was erected in connection with a church at Manny's Corners, and for 14 years, services were held alternately in the two churches. The Hagaman church was known as the North Church, and the other was known as the South Church. In 1850, a separation of the churches took place, most of the South Church congregation going to Hagaman, and soon after, the Manny's Corners church burned to the ground. (HHS.)

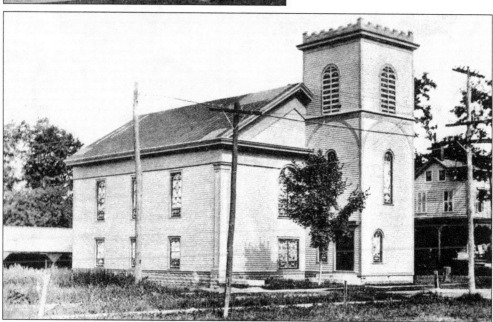

The Methodist Episcopal church in Hagaman began as a class meeting in the kitchen of the William Clark home on Inman Hill. It was taken over by the Methodist Episcopal pastor from Galway, and the church was built in 1863. This 1913 view shows the church as it looked before a major fire in 1923 forced a major reconstruction of the edifice. (HHS.)

The women of the Hagaman Bicycle Club pose in front of the Mosher home on Haskell Street on July 18, 1882. The woman standing second from the left is identified as Maude Blanch Mosher. (H&A.)

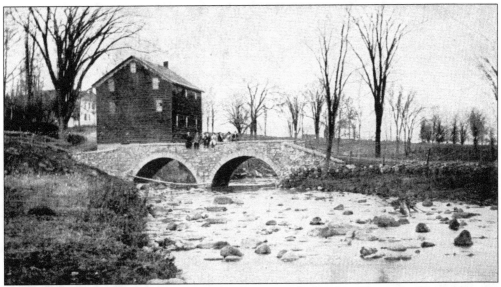

Conners Bridge was a stone span across the Chuctanunda Creek in Hagaman. The bridge may have gotten its name from James Conners, a local farmer who also owned a grist- and sawmill in Hagaman's Mills. (HHS.)

This image is looking north on Haskell Street in Hagaman about 1908. At left is the newly finished district elementary school. (HHS.)

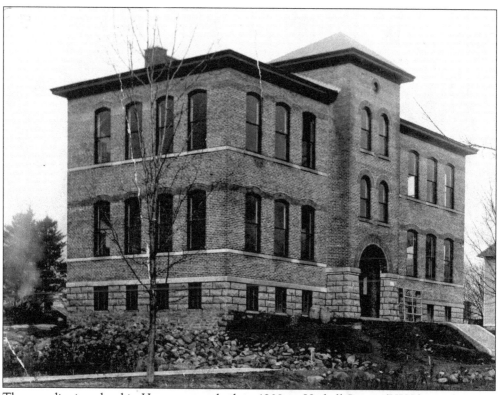

The new district school in Hagaman was built in 1908 on Haskell Street. (HHS.)

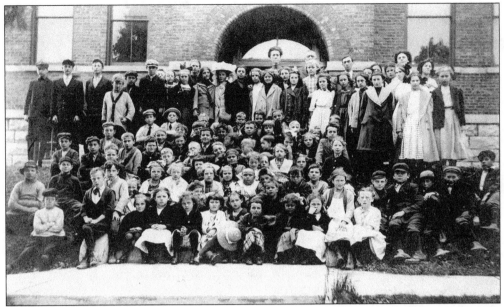

Students and teachers pose in front of the Hagaman School on Haskell Street about 1910. Lewis C. Banta is included in the picture, and George A. Buchanan is standing second from the right in the back row. (HHS.)

Retiring principal George A. Buchanan shakes hands with new principal Harvey Nelson in front of the new elementary school in Hagaman in 1956. Buchanan was a teacher for 55 years, 44 of which he served as the principal of the Hagaman School. He was a member of the Calvary Reformed church and served for 35 years as its treasurer. He served as village clerk for 10 years. At his death in 1957, he was remembered as a kindly and tolerant man with a warm human nature that earned him high respect in the village. (HHS.)

Visit us at
arcadiapublishing.com